French Primitive Photography

introduction by Minor White

commentaries by André Jammes and Robert Sobieszek

an Aperture Book · New York 1970

French Primitive Photography is an exhibition presented by the Alfred Stieglitz Center of the Philadelphia Museum of Art from November 17th through December 28th, 1969. It is published as *Aperture, Volume 15, Number 1,* as a catalogue for the exhibition, and as a clothbound book for general distribution.

The publication is set in Baskerville by TypoGraphic Communications, Inc. It was printed by Rapoport Printing Corporation. The paper, Caress—Basis 80, was manufactured by Monadnock Paper Mills, Inc. The design is by Sam Maitin.

Aperture, Inc. is a non-profit, educational organization publishing a Quarterly of Photography, portfolios, and books to communicate with serious photographers and creative people everywhere. Address: 276 Park Avenue South, New York City.

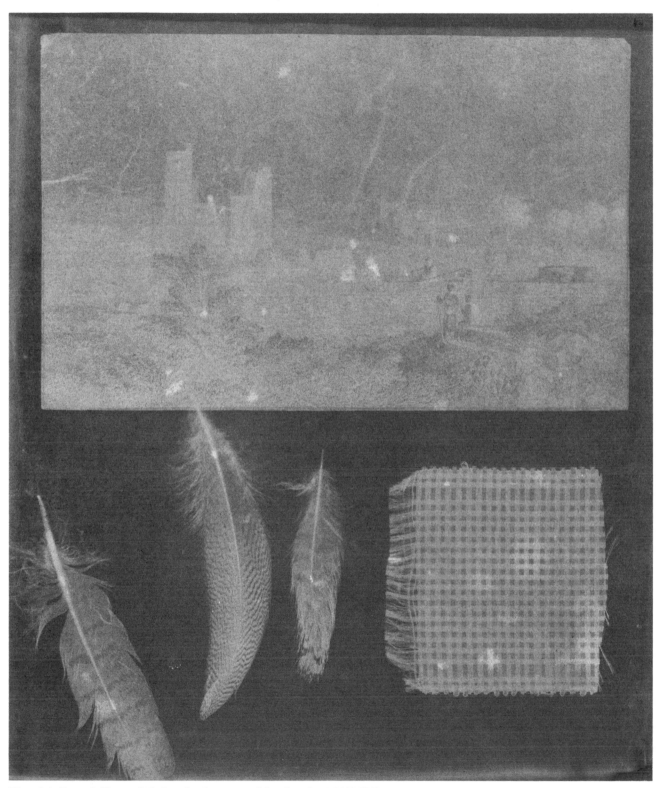

Hippolyte Bayard: Nature Printing: feathers, material, print, about 1839-1842.

Collecting the images of the early photographers has been the passion of André Jammes for years. We owe him gratitude for his efforts to retain the first full flowering of photography a century ago. For though photography was born or invented in both England and France at the same time, it was France that the muse of photography first graced.

What more possible time for photography to appear than in the Second Empire when art was once again at a peak of verisimilitude, except those previous times when the pendulum of visual expression swung to realism. How symbolic it was that among Hippolyte Bayard's earliest photographs are images of plaster casts of classic Greek and Roman sculpture. Verisimilitude in the art of the Second Empire had a different aim than realism in classic Greece. In Greece the ideal was the perfection of man; in the Second Empire the aim was the imitation of man.

In his dual role of Managing Editor —Publisher of Aperture and Advisor to the Alfred Stieglitz Center of the Philadelphia Museum of Art, Michael Hoffman first suggested the exhibition to André Jammes in Paris, the summer of 1968. It was through his efforts that the exhibition was organized for the Museum and this publication realized. The two hundred or so widely varied photographs sent by M. Jammes for the exhibition were augmented by loans from the French Photography Society, George Eastman House, and the Metropolitan Museum of Art. The structuring of the exhibition was loose but basically chronological. To crystallize the show for *Aperture* the pictures were edited into a contemporary viewpoint. On another level, André Jammes lovingly recapitulates the *then* of the images with his captions. Our sequencing of the images puts them in the present because of all that time has done to them since.

The French primitive photographers, as well as men of other nations, unconsciously worked with and showed the major characteristics of unique photography: scrambled time, communication without syntax, exactly repeatable images, mutual inward mirroring of the photographer and the world, the possibility of direct manifestation of the moment of revelation. Of the latter, the picture *Turkish Stèle* by Pierre Trémaux is an example.

Apparently photography was born unique, though at that period the uniqueness may not have been as clear as later. Painting and photographs looked so much alike that book reproductions wipe out the differences easily, if not to the expert eye, then certainly to the casual eye.

In the beginning was the photograph, and the photograph has never deviated from its unique norm. Photography, in its history, has recorded and enlivened philosophies about the changes of styles in dress and machines, the morés of societies, equipment and materials, and varied attempts to manipulate its medium into an emulation of painting. The unique photograph persists. For example, the woman on the cover of this issue looked the long hard look straight through the camera, through time to each individual of us now. People have been looking through cameras the same way ever since.

From the start, the photograph has retained its primary magic, that of being able to record the fact, feeling, and structure simultaneously at the moment of revelation—whether the photographer saw it or not, then or later. The primitives worked with the photograph, innocently or naively, so we read, in amazement at its power to reflect the detailed minutiae of surface, volume, and light. They were entranced by and gave all their attention to the photograph and knew little or nothing of the medium.

The medium, however, was present ...in the negative. Only their objective of verisimilitude kept them from exploring these negatives. They may have never exhibited these negatives as if they were images, as we have done in both exhibition and catalogue. Most likely, to exhibit a *step* in the process never entered their minds. But they saw them every day. They frequently looked at the primary alteration of vision and scene incorporated in the negative. It was in their hands. By accident, through technical failures, by trial and error printing, they also must have seen positives that were deviations from the realistic and literal.

The image survivals of the primitives are full of deviations from the literal. Assumed to be technical flaws today and thought to be stations on the way to verisimilitude by the makers, they function now as manifestations of moments of revelation both in the photograph of the subject and in the changes brought about by inadequate technique and the changes time has wrought since.

Whatever these images started out to be, they have become a kind of myth. Seeing them only as historical examples is missing half the message. They have been changed by time. These images are both youthful and aged. A reversal typical in photography occurs—these images we casually think of as grandparents turn into grandchildren! This is a myth we believe because as we become parents, observing our children causes us to relive our childhood *consciously for the first time,* to understand the primitive for the first time.

Public pictures by the camera were first made during the last months of 1839, but neither these very early works nor subsequent photographs generated from a vacuum. Picture making was as revolutionized by the camera as was the photograph a part of current pictorial sensibilities. The height of Romanticism's literary emotionalism had been reached in painting and literature during the 1820's. By the following decade, the intensity of this attitude had begun to wane and merge with other ideals. Théodore Géricault had died in 1824. Eugène Delacroix lived until well after mid-century, but he became more classicizing during the forties and fifties. The concentrated terror and energy of the *Death of Sardanapalus* (1827-1828) is noticeably absent from his later mural commissions. And when this artist's romanticism is continued by the younger painter Théodore Chassériau, it is blended with the mannered classicism of his teacher Ingres.

Undoubtably the most important and popular aspect of French painting during the first years of photography was precisely this amalgam of the romantic-picturesque and the calm abstraction of classicism. Not exactly constituting a style, a group of painters, the *juste milieu,* gained public notice and acclaim by being favored by the government of the July Monarchy. Paintings by Paul Delaroche, Horace Vernet, Robert Fleury, and Léon Cogniet were all successful in at least one common goal: they told a simple story without confusion or obfuscation. A taste for pictorial exactitude was combined with a desire to be popularly agreeable, a combination that could only guarantee success.[1] Purely aesthetic qualities, such as the texture of paint, correctness of anatomy, and perspective were subsumed by the storytelling and its subject matter. The writer Alphonse Karr described the popular attitude at the time.

The public...pays no attention to these qualities which it does not see; it troubles itself only with the subject. If it sees a battle, it wants to know which one it is; if the French are victorious, then the painting is immediately better.[2]

Subjects like Delaroche's *Death of the Duke of Guise* (1835) or Vernet's *Arab Chiefs at Council* (1843) are "romantic" in their history and exoticism. The disinterestedness of the treatment, however, and the almost journalistic presentation of the scene dilutes any potentially emotional impact. At once, both the abstractions of Classicism and the extremes of Romanticism were avoided. The resultant realism and literalness were welcomed

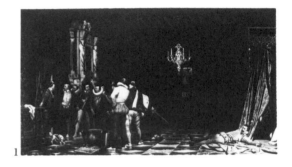

1

by a public who knew little of art, the same public who had greeted photography enthusiastically.

Throughout the century, Salon or "academic" painting was unquestionably the most observed and well received; later painters such as Meissonnier and Gérôme continued many of the characteristics of the *juste milieu.* The realism incipient to this earlier group was carried even further toward a social as well as a pictorial realism by artists like Courbet, Manet, and Charles Meryon. After the revolutions of 1848, there occurred a concern for everyday subject matter second only to the Dutch genre painters of the seventeenth century. As a movement, Realism lasted slightly more than a decade, but it was an attempt to satisfy public need for an understandable art. The more progressive critics claimed that traditional subject matter was no longer applicable to modern life; the language of Classical antiquity and of Christianity could no longer be understood by the spectators of the Second Empire.[3] What was needed was a pictorial style that dealt with modern man and his social environment. To this end both Realism—along with the *juste milieu* and the landscapists—and photography provided pictorial solutions.

Photography was invented in France by Hippolyte Bayard in 1839. The groundwork for Bayard's discovery was provided by the experiments conducted by the Englishman Henry Fox Talbot. Although Talbot is usually accredited with the discovery, it is a matter of record that Bayard made *and* exhibited positive, paper prints as early as June 24, while Talbot did not make his definitive process public until late 1840.[4] The daguerreotype process was worked on from the late twenties and publicized in August of 1839; daguerreotypy was not photography however. The daguerreotype is a unique picture on metal unable to be reproduced, while photography makes use of

a negative-positive technique that facilitates replication. The different pictorial qualities of the two processes are even more important. The daguerreotype is marvelously precise in details, but the picture is fairly small in scale and the surface highly reflective. The early paper photographs are capable of sensitively rendering effects of light and mass more delicately than the daguerreotype. Certain calotypes in the exhibition present scenes or landscapes that appear to be literally suffused with an atmospheric luminosity. Many of these pictures, especially those by Bayard and Le Secq, are most exciting for us because of this delicate radiance. Scale is also an important factor. Almost the entire effect of these pictures would be destroyed if preciously presented in a minute leather case lined with velvet.

From the beginning the early photographers, the "primitives," attained the facility for creating incredibly accomplished pictures. By no means were they primitive in their inability to fully utilize the materials given them. The stark expressionism, crude and monolithic forms, and the programmatic symbolism of many primitive cultures are absent in their work. Rather, there is a primitivism of simplicity, of reverence to material nature, and of non-artifice—except perhaps the artifice of directness. The majority of the photographers gathered in this exhibition made no attempt to duplicate specific painterly problems or to translate paintings into their own medium. In France this confusion of visual languages did not occur to any degree until much later in the century. The primitives were fascinated with the mystery and power that an unequivocal rendering of their world would impart. There is something rather naive about their approach to nature, an approach difficult to apprehend after decades of experimental mutation of the photographic image, but not without rewards for the attempt.

As André Jammes states elsewhere in this issue, many of the early photographers were painters by trade when they came to the new device. Those that were not were at least in some way connected with the recognized artistic community in Paris. Bayard was a close friend of the painter Amaury Duval, a pupil of Ingres, the leader of the Classicist School. Gustave Le Gray, Charles Nègre, the elder Bisson, Charles Marville, and Louis Robert were all painters in their own right; some relinquished the brush entirely while others continued in both media. These names have left little mark on the history of art; for the most part they were not eminently successful as painters. Many of them issued from what generally has been called bohemianism: painters unsuccessful in making a name, writers existing by an occasional article, and engravers whom photography had somewhat displaced.[5] Yet around some of them the more noted celebrities of Parisian art gathered. At the Bissons' studio, for example, one could have met the novelist Théophile Gautier, the art critic Jules Janin, Delacroix, and Chassériau.[6] Charles Baudelaire knew the Bissons and admired both Nadar and Carjat.

The *juste milieu* painter Horace Vernet was in Egypt with the daguerreotypist Goupil-Fesquet in 1839, while ten years later Maxime Du Camp traveled the Orient with Gustave Flaubert. In such a climate it was impossible for photography to be an isolated cultural phenomenon.

The primitives were not tangential to the main currents of the period, nor were they beleaguered starving misfits. Photography was given official pictorial sanction throughout the 1850's by the government of the Second Empire. In 1851, the *Commission des monuments historique* authorized Le Gray, Le Secq, Baldus, Bayard, and Mestral to document the architecture and scenes of the French nation. Later in the decade the Administra-

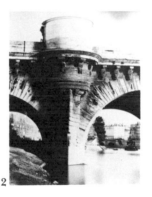

2

tion purchased other photographic collections; Belloche's series of the hotel where General Bonaparte had resided and the Mayer frères' stereoscopic views of Dutch paintings are just two of presumably many such commissions.[7]

During the following decade, due to wars and other economic considerations, the official purchase of photographs diminished, while individual patronage increased substantially. The albums and portfolios that were privately commissioned remain among the unquestionable masterpieces of this period. In 1860, Bisson frères were assigned to portray Mont Blanc and its surrounding glaciers as a souvenir of the Royal Family's excursion into the *Haute Savoie*. Charles Nègre documented the Imperial Asylum at Vincennes for the Emperor in the same year. And most likely it was during the first years of this decade that the Baron James de Rothschild hired Baldus to photograph the views and archi-

tecture along at least two railroad lines outside of Paris. The two large folio albums that resulted—excluding a possible smaller album whose attribution is in question—present a new type of landscape, an industrial landscape whose terminals, tracks, and bridges are treated with as much understanding and picturesqueness as any purely natural view.[8] Close to twenty years previous, Gautier understood that the by-products of industrialization were as much a part of man's environment as nature

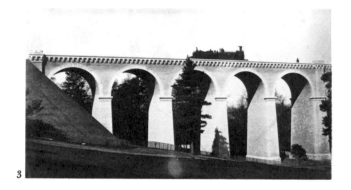

3

itself. In order to retain a vital currency, the arts had to portray what was important to modern society; furthermore, Gautier claimed that "the modern Pegasus will be a locomotive."[9] Both official government and individual commissions demonstrate that while certain painters scorned the new process throughout the century, the photographers were not without a public and a patron. Independence was granted to photography almost from the beginning as long as it held to its internal limits. The major difficulties arose only when photographers self-consciously confused their picture making with what was then High Art.

Photography evolved during its first few decades within an intellectual environment that extolled scientific particularism, materialism, and naturalism. Social philosophies like Positivism continually emphasized the behavioral study of nature and of social objects. What was of importance was the reality that constantly affected a person; for the Positivists Auguste Comte and Ernest Renan, for example, the scientific examination and objective understanding of material nature were the hope for the future. The artist was expected by the Positivists to see nature much as the scientist did: with total disinterest and objectivity. The movement called Realism in both literature and painting drew heavily from this attitude. Scientific exactitude and faithful reproduction of reality were for Realism necessary for the work of art. Flaubert phrased it most succinctly when in 1857 he wrote:

"the artist ought to be in his work like God in creation, invisible and omnipotent. He should be felt everywhere but not be seen. Art ought, moreover, to rise above personal feelings and nervous susceptibilities! It is time to give it the precision of the physical sciences, by means of a pitiless method!"[10]

Realism claimed as subject matter for the artist anything and everything that belonged to nature, with the implicit emphasis on material nature. The non-material subjects of fantasies and romantic fictions were not considered legitimate areas for the artist. "Art…is a real thing," claimed the first editorial of the art review *Réalisme*, "existing, visible, and palpable: the scrupulous imitation of nature."[11] Yet neither Courbet, Millet, Manet, nor any other Realist painter discarded their brushes in front of photography. Nor paradoxically did any of the critics and theoreticians of Realism welcome the photograph as a possible fulfillment of their aesthetic criteria. Suffice it to say that the French primitive photographers gave their pictures to an audience whose sensibilities were determined in a large part by a fully materialistic outlook. The naturalism of the photograph, its relative veracity in picturing a world of increasing interest, and its apparent scientific objectivity could not but delight such an audience.

More than anything else, photography contributed most heavily to a popular desire for pictures of the current world. In French painting there had been a steady progression since David toward a more topical and contemporaneous subject interest. David's pupil Gros painted a kind of monumentalized reportage as early as 1804 by illustrating Napoleon not on the battlefield but in a pesthouse at Jaffa. The guise of the Emperor may be heroic, but his surroundings are an actual part of contemporary reports. Even more journalistic was Gericault's method of working on his gigantic melodrama *The Raft of the Medusa* (1819). Basing his picture on newspaper reports and eyewitness accounts, Géricault succeeded in composing a baroque rendition of a newsworthy episode with immediate currency. In 1835, the painter Boissard exhibited his *Episode from the Retreat from Russia*; all the heroism of Gros or the charged emotionalism of the Géricault are gone. In a rugged, snow-covered landscape lie two soldiers and a horse, dead and deformed; and in the words of a contemporary editor, the work was "shocking in its truth."[12]

The pictorial reporting of contemporary scenes did not necessarily limit itself to the most celebrated or dramatic. The common and everyday was also a tenable concern. The 1830's and 1840's saw the novels of Alfred de Musset and Balzac replete

with descriptions of commonplace objects and vulgar realities. The popular songs of Pierre Dupont during the late forties contained similar elements. An increased publication of popular woodcuts and engravings also occurred. Painting was not divorced from these trends; in 1845, Baudelaire wrote:

the heroism of modern life *surrounds and presses upon us.... There is no lack of subjects, nor of colors, to make epics. The painter, the true painter for whom we are looking, will be he who can snatch its epic quality from the life of today and can make us see and understand, with brush or with pencil, how great and poetic we are....*[13]

The everyday, both in genre and history painting, was to become the most important subject, as was the landscape for the Realist and the Impressionist. Current events and the commonplace were also of primary importance for the primitive photographers. Colonel Charles Langlois, as well as Fenton and Robertson, had "covered" the Crimean War much as a present-day photojournalist would. The absence of images of death and the delicate treatment of the print distinguish it markedly, however, from any twentieth-century parallel. The diasastrous floods in the south of France in 1865 were similarly reported by the camera. Baldus' pictures of this event gained praises for their eloquence and their objectivity.

"Reality became as a source of aesthetic joys equal or superior to any other" during this period.[14] A major part of this joy was due to a desire for the topographic evidence of place, for a naturalistic knowledge of the world and man's creations. Photography amply supplied the best evidences of the world; it was better than actual travelling since the photograph could be retained and referred to again. The thousands of negatives taken of the monuments and views of France during the fifties alone provided a repertoire of detailed visual experiences unknown before photography. The primitive photographer came close to the botanist or naturalist in his direct approach to a systematic inventory of subject. Yet it was an inventory made by a naturalist sensitive to what he observed, conscious of the effects of light upon the scene and the play of masses and contours in the picture. He was also a primitive in that he was naively infatuated with what he saw and photographed.

Marville's oneric street scenes fascinate the modern viewer because they illustrate the Paris that no longer survives, the small side streets and corners that Hugo and Balzac wrote of prior to the modernization of the city. Beyond nostalgic effect are a clarity of vision, a poetic enchantment, and a glorification

of the simple and unassuming that is common to all of the primitives. The same quality is found again later in the photographs of Robuchon and Atget. Le Gray's marines or Le Secq's architectural scenes are more monumentally constructed than most, but this is a matter of degree not of kind; for a directness

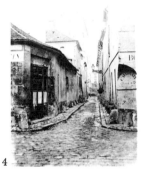

4

and relative simplicity are necessary for anything to be monumental, and for the primitive photographer, the lyricism of the real transcended other concerns.

During the nineteenth century the known world extended itself far beyond the borders of France. Since the campaigns of Napoleon at the beginning of the century, North Africa and the Middle East had become fascinating regions to the Parisian public. The pictorial artists in part reflected but also helped engender the popular delectation for the exotic. Gros had followed Napoleon on his campaigns and had portrayed him in various locales. The Romantics like Delacroix and Chassériau found in the Orient the vibrant colors, the strange atmosphere, and the costumes and physiognomies so wonderful in their foreign countenance. And although Delacroix claimed to have discovered in North Africa the reincarnation of classical antiquity, his pictures of massacres and hunts contain all the emotionalism of the High Baroque. The Romantic painters and novelists had provided their audiences with a taste for the exoticism and mystery of the Orient, a taste that would remain active for many decades.

Orientalism in painting underwent at least one important modification during the first half of the century. The earlier artists—Delacroix, for example, and even Ingres—saw in foreign lands only the raw materials and experiences for their personal statements and expressions; they simply molded the facts to their sensibilities. By mid-century the sensibility of many orientalists changed to one that accepted the apparent reality of the scene and subordinated the emotionalism of the artist's per-

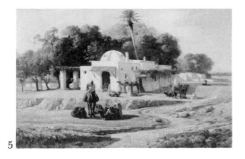

5

sonality to the detailed and exquisite rendering of nature. A few years before Delacroix made his first voyage to Africa, Alexandre Decamps was in Asia Minor, painting and sketching picturesque genre subjects. At the same time, the most famous of the Realist painters of the Orient, Prosper Marilhat, was traveling through Syria, Palestine, and Egypt. Marilhat combined in his paintings the "idealism of a great artist with the exactitude of an architect or a botanist"[15]; it was this same artist, along with Eugene Fromentin, who was at the head of a long tradition of artists who realistically portrayed the countries beyond the Mediterranean. Painters like Berchère, Tournemine, Dehodencq, Belly, and Guillaumet—forgotten names—provided the public with topographic evidences of strange places and visual records of a world beyond their sight. The taste for the exotic was a product of Romanticism, and even though these artists were far more topographic than Delacroix, they were as much a part of the romanticizing sensibility as the earlier painter. Romanticism contained an incipient naturalism almost from its beginnings; the naturalistic orientalists could not totally divorce their art from the literary or exotic subjects popularized by Romanticism.

The period in which these orientalists worked, the 1840's through the 1860's, coincided with the appearance of numerous publications illustrating foreign scenes and subjects. In 1835, the album of lithographs by Wyld and de Lessore, entitled *Voyage pittoresque dans la région d'Alger,* was published. The years 1840 to 1844 were marked by the large work (over one hundred plates in two volumes) of Lerebours's *Excursions daguerriennes.* Literally based on daguerreotypes, these engravings represented views from as far distant places as Athens, Moscow, Stockholm, Jerusalem, Baalbec, and Damascus. Théodore d'Aligny published his etched *Vues des sites les plus celebres de la Grece antique* one year later.

What engraved or etched views of various countries could provide by way of information and delectation, the photographic print could do as well, if not better, at times. The decade of the fifties witnessed an incredible array of photographic orientalism.

Commencing with Du Camp's *Egypt, Nubia, Palestine, Syria* in 1852, other photographers voyaged to the Near East and returned with pictures unmatched in their singular pictorial beauty. De Clercq's and Salzmann's views of Jerusalem, Trémaux's Sudan, and Du Camp's Egypt showed a world already hinted at by literature and painting in hitherto unforeseen detail. But more than sheer documentation, all of these pictures, as André Jammes points out concerning Salzmann, combine a precision of the minute with a textural beauty, a luminosity, and a sensitively felt reverance toward what was photographed. Some of Du Camp's general views could compare favorably pictorially with any of Marilhat's oriental scenes such as his *Oriental Caranvanserai* (1840's) presently in the Philadelphia Museum of Art.

The *musée imaginaire* of the world extended beyond the Middle East. In the early forties, d'Urville and Siebold had made daguerreotypes of the Pacific and Japan, but the larger range of the photograph brought these unknown regions to an ever increasing audience. Gustave Viaud photographed Tahiti in 1859, over thirty years before Gauguin arrived on the island. Periodi-

6

cally from 1857 to 1865, Désiré Charnay documented Central America and Mexico and produced some of the most mysterious and arcane images of the period; in 1863, he interrupted his

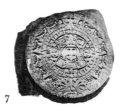

7

study of the Americas and photographed Madagascar. Apparently Charnay was a tireless traveler, for in 1878 he was in Chile and Java, and as late as 1897 he voyaged to Yemen.

The delectation for exotic foreign lands was not limited to monuments and views; the physiognomies of different races were also popularly demanded by interested ethnologists and an ever curious populace. E. Benecke photographed the Egyptians and Nubians in the same year that Du Camp was recording their monuments. The Muséum de Paris began its scientific collection of photographic portraits of Japanese and Chinese ambassadors

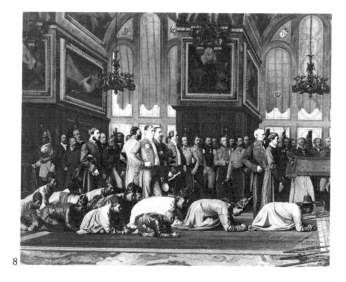

8

at this time, over a decade before Gérôme would paint his grandiose *Reception of the Siamese Ambassadors at Fontaine-bleau* (ca. 1864). Photographic portraits of North American Indians and Laplanders were made at the beginning of the sixties by Prince Roland Bonaparte, representing the earliest visual anthropological records of these peoples. These portraits do not affect any aesthetic viewpoint in order to produce an "artful" rendering of the visage; again, as with the primitive photographers of scenes and architecture, an uncomplicated and direct attitude on the part of the picture maker produced a clear and immediate understanding of the subject. Straightforward immediacy becomes an aesthetic in itself.

The general shift in pictorial art during the first half of the century was from an overt lyricism and charged expressiveness to a more detached and calm naturalism; not an absolute evolutionary progression by any means, the change was more a gradual displacement of one cultural sensibility by another. French primitive photography was not really affected by this shift. Because of the point in time at which it appeared and because of its own internal structure, photography was unable both culturally and technically to realize as broad a latitude of styles as had painting. Yet the diversity among the pictures in this exhibition attests to the new medium's incredible potential for varied stylistic approaches. The soft, gentle lyricism of Regnault's potraits—equal in strength and grandeur to any of David Octavius Hill's—or the dramatic chiaroscuro illuminating the profile of Victor Hugo recall the romanticized portraits of Delacroix or Corot. Nadar and Carjat are singularly independent of any school of portraiture. The simplicity and ruggedness that any

Realist would have desired, the clarity of outline, and the larger-than-life disposition of the figure comparable to Ingres's portraits of same period are but a few of the theoretically conflicting elements in these pictures. Yet these elements are responsible for the strength and the presence of this veritable gallery of notables. The officializing portrait style of Ingres and many of the *juste milieu* portraitists is repeated in a number of works by Disdéri, purportedly the figure who single handedly destroyed the art of the photographic portait. The pose according to formula, the artificial props, and the facile treatment of the sitter

9

became, after Disdéri, the constants of cheap, commercial studio portraits. And while Mme. Disdéri put together a delightful series of views in and around Brest, it would be difficult to consider her husband a primitive photographer in the context of this exhibition. His pictures are included only by way of contrast to those by Regnault, Nadar, and others.

Increased ubiquity of the photograph, as well as different aesthetic criteria, saw the end of primitivism in photography. Commercialism, the cinema, automated processing, and pictorialism replaced the simplicity and intuitive charm of the early photograph with other values—just as valid but extremely divorced in kind. One type of primitive photographer continued however: *le flâneur* photographer. He is a picture maker who strolls along the streets and roads of his environment and captures on film the scenes and images of modern life. In 1858, Victor Fournel said:

...It is not given to everybody to be able to amble [flâner] naively, that man is a mobile and empassioned daguerreotype who secures the most subtle traces, and in whom is reproduced, with their changing reflections, the march of things, the movement of the city, the multiple physiognomy of the public spirit, beliefs, antipathies and admirations of the crowd.[16]

Five years later, Baudelaire wrote of what he thought to be the ideal modern artist. "Observer, philosopher, *flâneur*—call him what you will;...he is the painter of the passing moment

and of all the suggestion of eternity that it contains."[17] It was this attitude that led Le Gray to photograph the scenes of military life in the camp of Châlons in 1858 at precisely the same time as Jean-Léon Gérôme painted a monumental version of the same scene in a Russian camp. Nègre was a *flâneur* when he

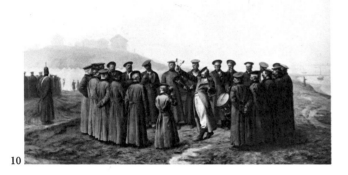
10

photographed his organ grinders, as was Manet when painting the *Music in the Tuilleries* (ca. 1860), and as Atget was when he portrayed the street vendors of Paris after the turn of the cen-

11

tury. Lartigue, Brassai, and Kertész are all of the same idiom, as is Cartier-Bresson. Finally the family snap-shot, pictures by anonymous amateurs and by unknown provincial documentarians—all reflect many of the identical sensibilities toward medium and subject: a naiveté, a simplicity of approach, and a primitivism of spirit.

Notes

1. Leon Rosenthal, *Du Romantisme au Réalisme,* Paris, 1914, p. 224.

2. Alphonse Karr, *Les Guêpes,* April, 1840, p. 67.

3. Cf. Jules Antoine Castagnary, "Le Salon de 1857," *Salons 1857-1870,* Vol. I (1892), pp. 7-11; and Théophile Thoré, *Salon de T. Thoré. 1844, 1845, 1846, 1847, 1848,* Paris, 1868, p. xxxix.

4. Georges Pontoniée, *The History of the Discovery of Photography,* trans. by Edward Epstean, New York, 1936, p. 186.

5. Gisèle Freund, *La photographie en France au dix-neuvième siècle,* Paris, 1936, p. 49.

6. Nadar, *Quand j'étais photographe,* Paris, n.d. 1900, p. 203.

7. Pierre Angrand, "L'Etat mécène, période authoritaire du Second Empire (1851-1860)," *Gazette des Beaux-Arts,* LXXI (May-June, 1968), p. 315.

8. Examples of all three albums are in the collection of the George Eastman House, Rochester, New York.

9. Théophile Gautier, "Salon de 1846," *La Presse,* (March 31, 1846).

10. Letter to Mlle. Leroyer de Chantepie, March, 1857, in Gustave Flaubert, *Extraits de la correspondance or préface à la vie d'écrivain,* G. Bollème, ed., Paris, 1963, p. 188.

11. *Réalisme* appeared initially in July, 1856. Cited in Freund, *op. cit.,* pp. 105-106.

12. Anon., *Annales du musée, Salon de 1835,* Paris, 1835, p. 42.

13. Charles Baudelaire, "The Salon of 1845," in *Art in Paris, 1845-1862, Salons and Other Exhibitions,* trans. by Jonathan Mayne, London, 1965, p. 32.

14. Rosenthal, *op. cit.,* p. 386.

15. René Lanson, "L'Orient romantique," in Louis Hautecoeur and others, *Le Romantisme et l'art,* Paris, 1928, p. 264.

16. Victor Fournel, *Ce qu'on voit dans les rues de Paris,* Paris, 1858, p. 261.

17. Charles Baudelaire, "The Painter of Modern Life," in *The Painter of Modern Life and other Essays,* trans. by Jonathan Mayne, London, 1964, pp. 4-5.

List of Illustrations

Selected Bibliography

This bibliography is by no means exhaustive. Only the most important and most readily available citations have been included. Individual articles in periodic literature of the period have not been listed because of size limitations. The two major photographic reviews of the 1850's and 1860's however, have been cited.

Anon., "The Victor Hugo Album," *Image* (Rochester), I, No. 7, (Oct. 1952), pp. 1-2.

Anon., "Early Photography in Yucatan," *Image* (Rochester), II, No. 5 (May 1953), pp. 28-29.

Aragon, E. Sougez, George Besson, F. Tuefferd, "La photographie ancienne," *Le Point*, XXIII, n.d. (ca. 1942).

Pauline V. Asher, "Photography," *Pre-Impressionism 1860-1869, a formative decade in French art and culture*, (Exhibition catalogue), Davis: University of California at Davis Memorial Union Art Gallery, 1969, pp. 75-77.

Charles Baudelaire, "Le public moderne et la photographie," ("Salon de 1859") *Curiosités esthétiques*, Paris, 1923, pp. 264-272. Trans. as "The Modern Public and Photography," by Jonathan Mayne in *Art in Paris, 1845-1862, Salons and Other Exhibitions*, London, 1965, pp. 149-155.

George Besson, *Photographie française 1839-1935*, Paris, 1934.

(George Besson), *Un siècle de technique: Etablissements Braun & Cie.*, n.p. (Paris), n.d. (1948).

L. D. Blanquart-Evrard, *La photographie, ses origines, ses progrès, ses transformations*, Lille, 1869 & 1870.

H. Th. Bossert and H. Guttmann, *Les premiers temps de la photographie, 1840-1870*, Paris, 1930.

Michel F. Braive, *L'Age de la photographie*, Bruxelles, 1965. Trans. as *The Photograph, A Social History*, by David Britt, New York, 1966.

Michel F. Braive, "The History and Legend of Nadar," *Camera* (Lucerne), XXXIX, No. 12 (Dec. 1960), pp. 13-16.

Philippe Burty, "Exposition de la Société Française de Photographie," *Gazette des Beaux-Arts*, II, 1859, pp. 211-221.

Yvan Christ, *L'Age d'or de la photographie*, Paris, 1965.

Yvan Chirst, "Les premiers voyageurs photographes," *Jardin des arts*, No. 152-153 (July-Aug. 1967), pp. 26-37.

Yvan Christ, "Le temps des crinolines à travers les vues stéréoscopiques," *Jardin des arts*, No. 91 (June 1962).

Anne d'Eugny and René Coursaget (ed.), *Au temps de Baudelaire, Guys et Nadar*, 1945.

Essen: Museum Folkwang, *Die Kalotypie in Frankreich. Beispiele der Landschafts-, Architektur- und Reisedokumentationsfotografie*, (Exhibition catalogue), Essen, 1965.

Essen: Museum Folkwang, *Hippolyte Bayard, ein Erfinder der Photographie*, (Exhibition catalogue), Essen, 1960.

Louis Figurier, *La photographie au salon de 1859*, Paris, 1860.

Gisèle Freund, *La photographie en France au dix-neuvième siècle. Essai de sociologie et d'esthétique*, Paris, 1936. Trans. into German as *Photographie und bürgerliche Gesellschaft, eine kunstsoziologische Studie* by Walter Benjamin, München, 1968.

Paul Gruyer, *Victor Hugo photographe*, Paris, 1905.

André Jammes, *Charles Nègre photographe*, Paris, 1963.

Marie Thérèse and André Jammes, "The First War Photographs," *Camera* (Lucerne), XLIII, No. 1 (Jan. 1964), pp. 2-38.

André Jammes and P. O'Reilly, *Gustave Viaud photographe de Tahiti 1859*, Paris, 1964.

Henri Jonquières, *La vieille photographie depuis Daguerre jusqu'à 1870*, Paris, 1935.

Alexander Ken, *Dissertations historiques, artistiques et scientifiques sur la photographie*, Paris, 1864.

Charles Kunstler, "Nadar et les catacombes," *Gazette des Beaux-Arts*, LXVI (July-Dec. 1965), pp. 91-96.

Ernest Lacan, *Esquisses photographiques à propos de l'Exposition Universelle et de la Guerre d'Orient*, Paris, 1856.

Ernest Lacan, "Physiologie du photographe/1853," *Terre d'Images*, No. 2 (March April 1964), pp. 217-235. Reprints of four articles that originally appeared in *La Lumière*, 1852-53.

Raymond Lécuyer, *Histoire de la photographie*, Paris, 1945.

Lo Duca, *Bayard*, Paris, 1943.

La Lumière, Paris, 1851 1861.

Nadar, *Quand j'étais photographe*, Paris, n.d. (1900).

Beaumont Newhall, "The Daguerreotype and the Traveler," *Magazine of Art*, XLIV (May 1951).

Beaumont Newhall, "Delacroix and Photography," *Magazine of Art*, XLV (Nov. 1952), pp. 300-303.

Paris: Bibliothèque Nationale, *Nadar*, (Exhibition catalogue; preface by Etienne Dennery.) Paris, 1965.

Paris: Bibliothèque Nationale, *Un siècle de vision nouvelle*, (Exhibition catalogue by Jean Adhémar and Jacqueline Armingeat). Paris: 1955.

Gerda Peterich, "The Calotype in France and Its Uses in Architectural Documentation," unpublished thesis, University of Rochester, Rochester, 1956.

Gerda Peterich, "Louis Désiré Blanquart-Evrard: the Guntenberg of Photography," *Image* (Rochester), VI, No. 4 (April 1957), pp. 80-89.

Georges Potonniée, *Histoire de la découverte de la photographie*, Paris, 1925. Trans. as *The History of the Discovery of Photography* by Edward Epstein, New York, 1936.

Jean Prinet and Antoinette Dilasser, *Nadar*, Paris, 1966.

Claude Roy, "Le Second Empire vous regard," *Le Point*, LIII-LIV, 1958.

Aaron Scharf, *Art and Photography*, London, 1968.

Aaron Scharf, "Camille Corot and Landscape Photography," *Gazette des Beaux-Arts*, LIX, 1962, pp 99-102.

Aaron Scharf and André Jammes, "Le réalisme de la photographie et la réaction des peintres," *L'Art de France*, IV, 1964, pp. 174-189.

Hazen Sise, "The Seigneur of Lotbinière—His 'Excursions daguerriennes,'" *Canadian Art*, IX, (Autumn 1951), pp. 6-9.

Bulletin de la Société Française de Photographie, Paris, 1855-1914+.

Emmanuel Sougez, *La photographie, son histoire*, Paris, 1968.

Emmanuel Sougez, "This Nadar," *Camera* (Lucerne), XXXIX, No. 12 (Dec. 1960), pp. 23-26.

F. A. Trapp, "The Art of Delacroix and the Camera's Eye," *Apollo*, LXXXIII, No. 50 (April 1966), pp. 278-288.

André Vigneau, *Une brève histoire de l'art de Niepce à nos jours*, Paris, 1963.

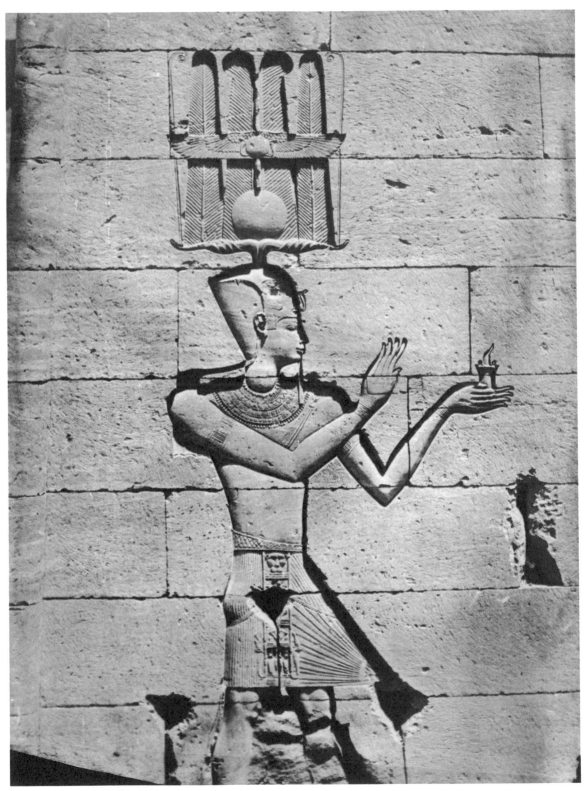

Maxime Du Camp: Nubia 1851

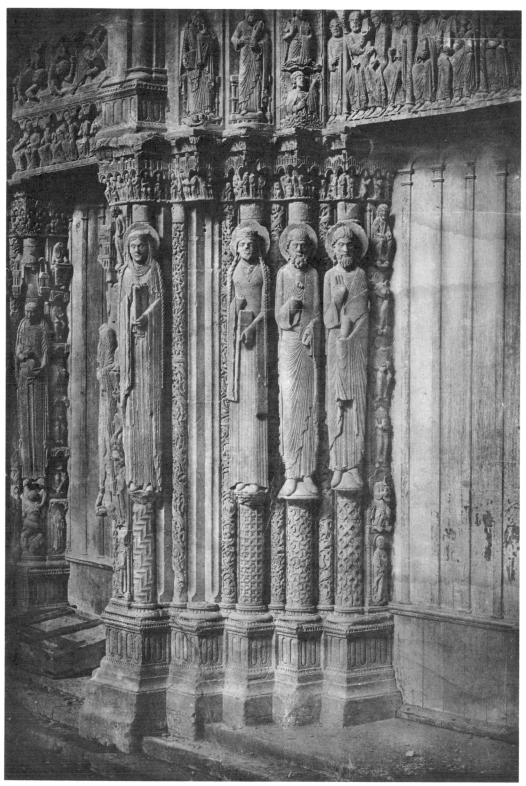

Charles Nègre: Chartres Cathedral 1855 (photogravure)

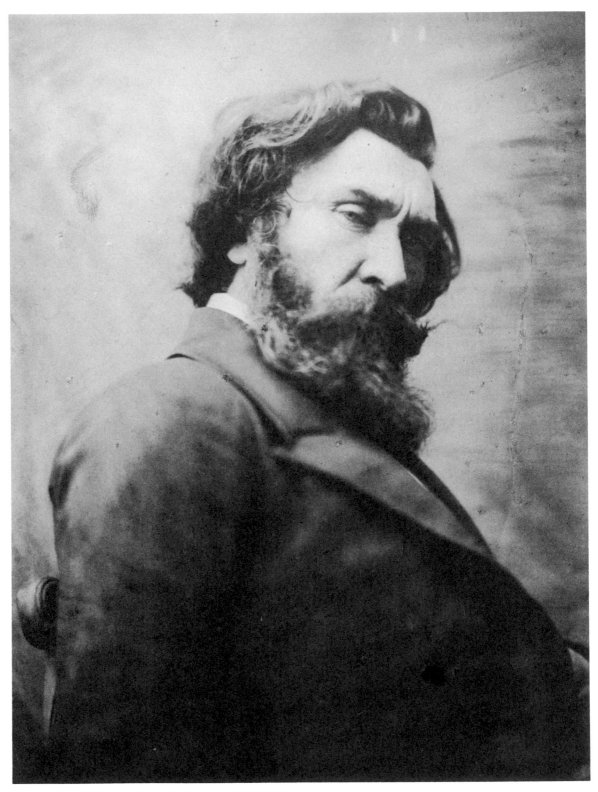

Photographer Unknown: Portrait of a man ca. 1855-1860

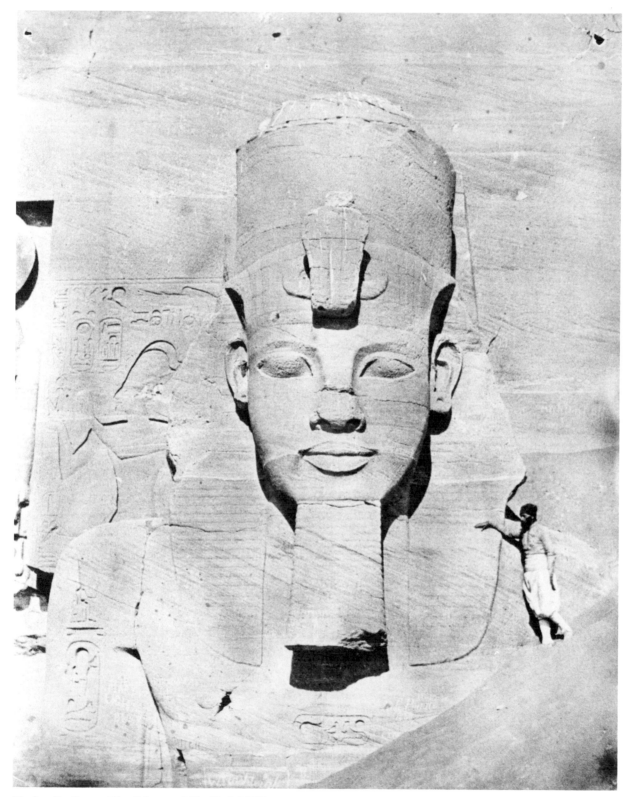

Maxime Du Camp: The Colossus of Abu Simbel 1851

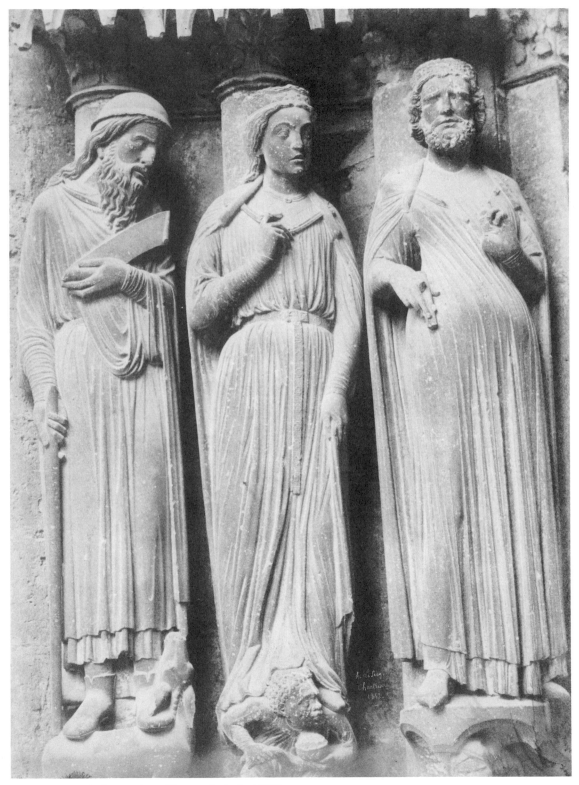

Henri Le Secq: Sculptures from Chartres Cathedral 1852

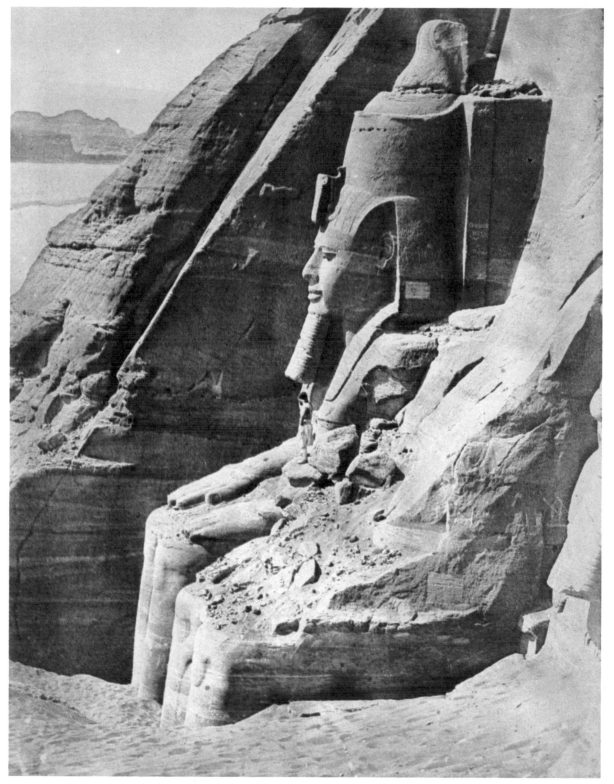

Maxime Du Camp: The Colossus of Abu Simbel 1851

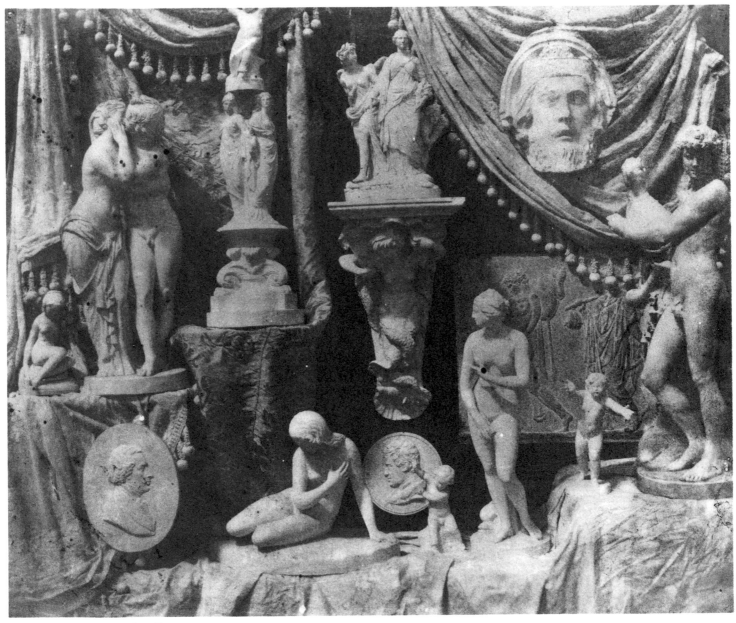

Hippolyte Bayard: Still life 1840

Hippolyte Bayard: Attic ca. 1846-48

Hippolyte Bayard: Self Portrait ca. 1846 (calotype)

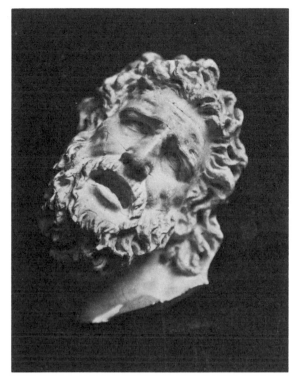

Duchenne de Boulogne: *The modeling of the sides of
the forehead is impossible* 1862

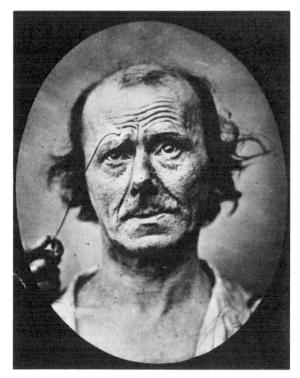

Duchenne de Boulogne: *Memory and Stimulus
to Remembering* 1862

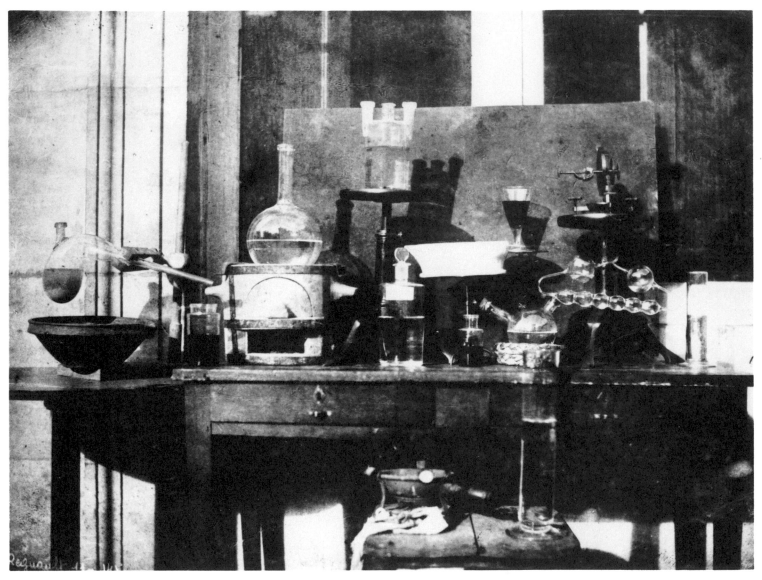

Victor Regnault: Laboratory Instruments ca. 1851

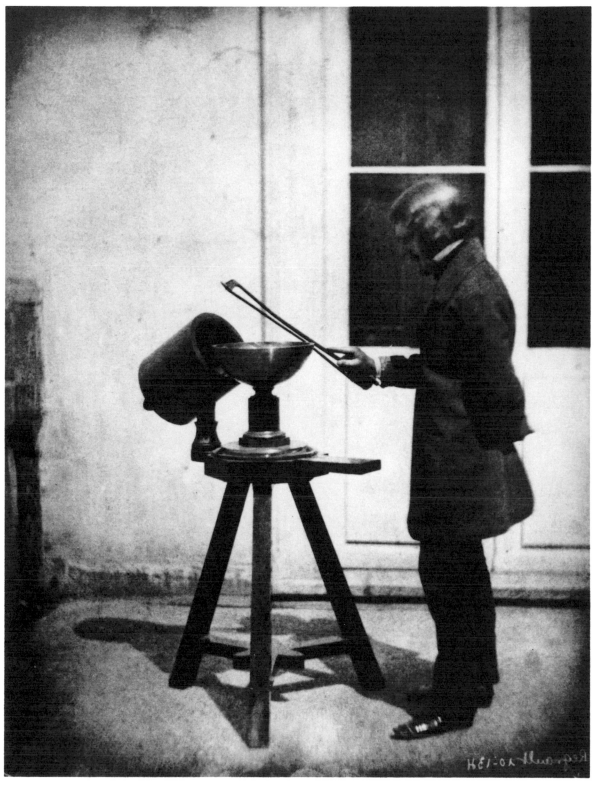

Victor Regnault: Acoustical Experiment ca. 1851

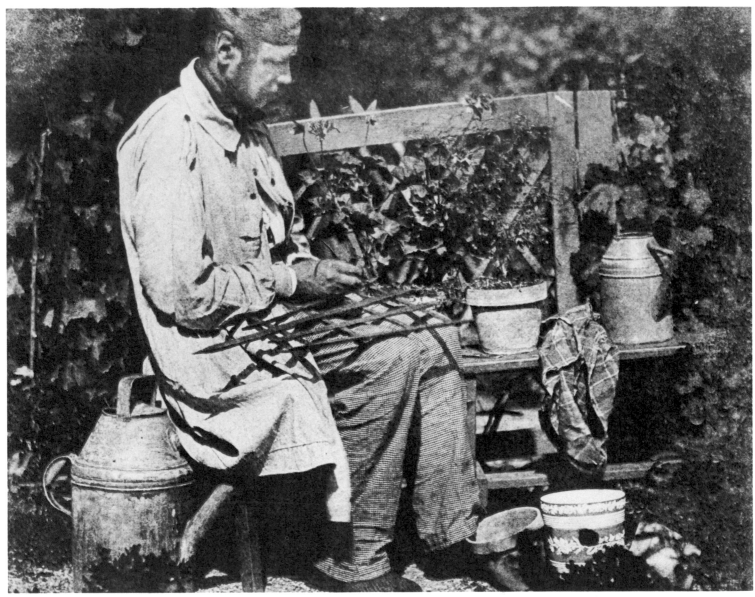

Hippolyte Bayard: Self Portrait ca. 1846 (calotype)

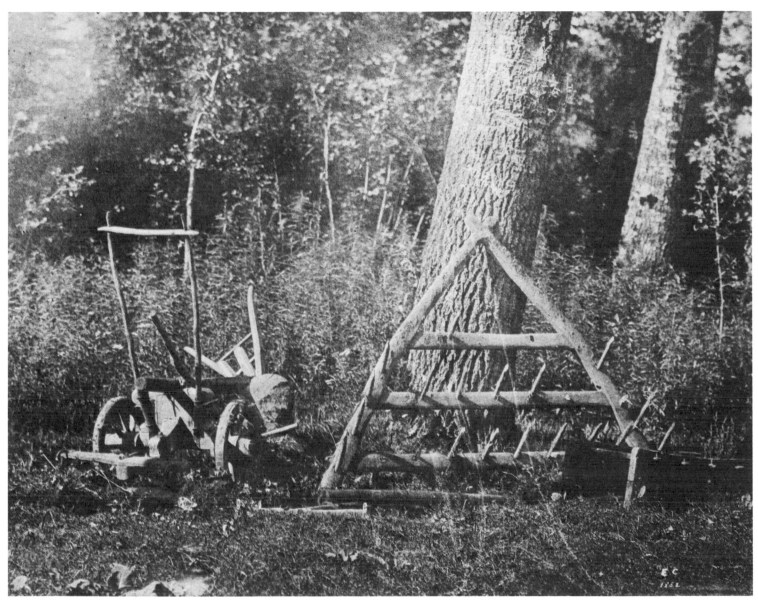

"E.C.": Agricultural implements 1852

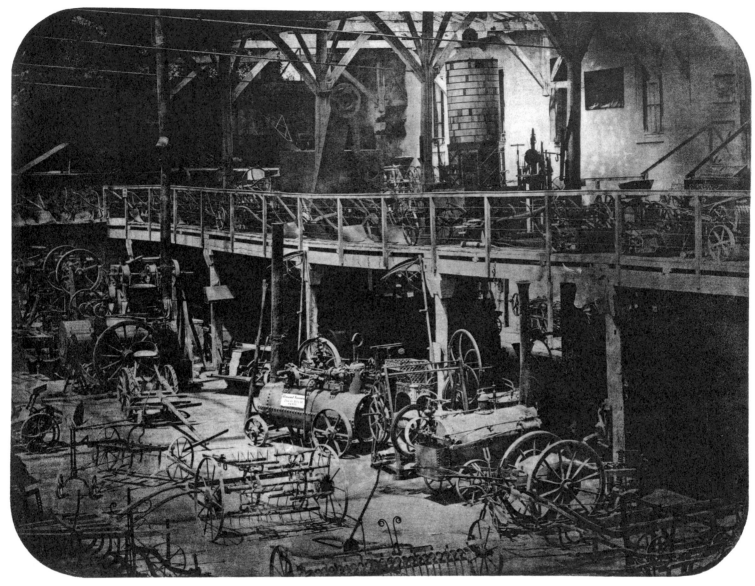

Piallat: Warehouse of agricultural implements (photolithograph)

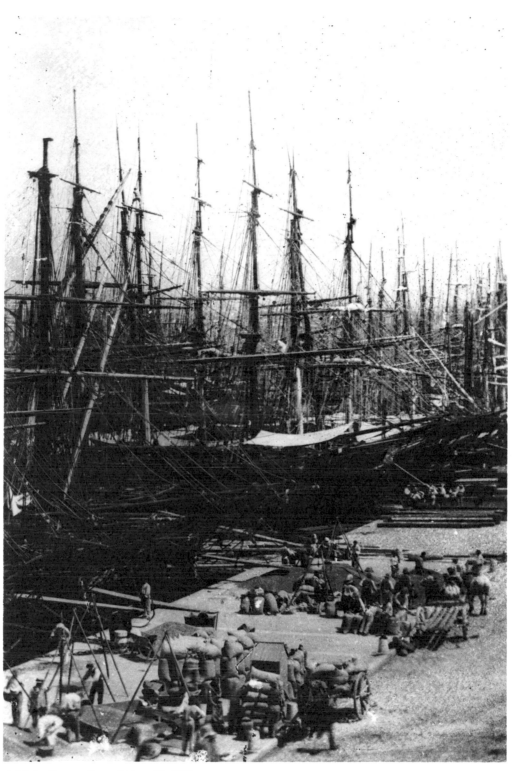

Adolphe Braun: Port of Marseille 1855

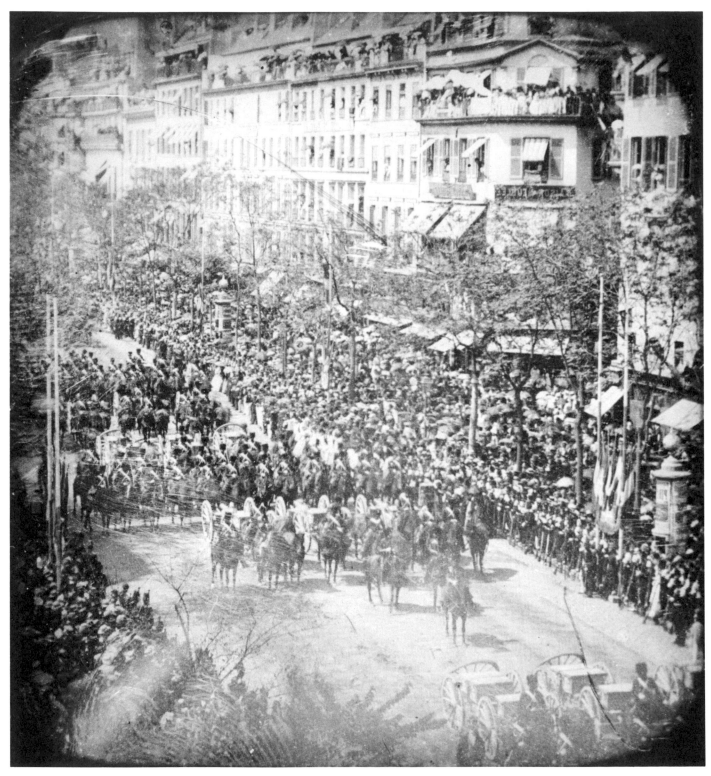

Unknown: Return of the Troops from Italy 1852 (daguerreotype)

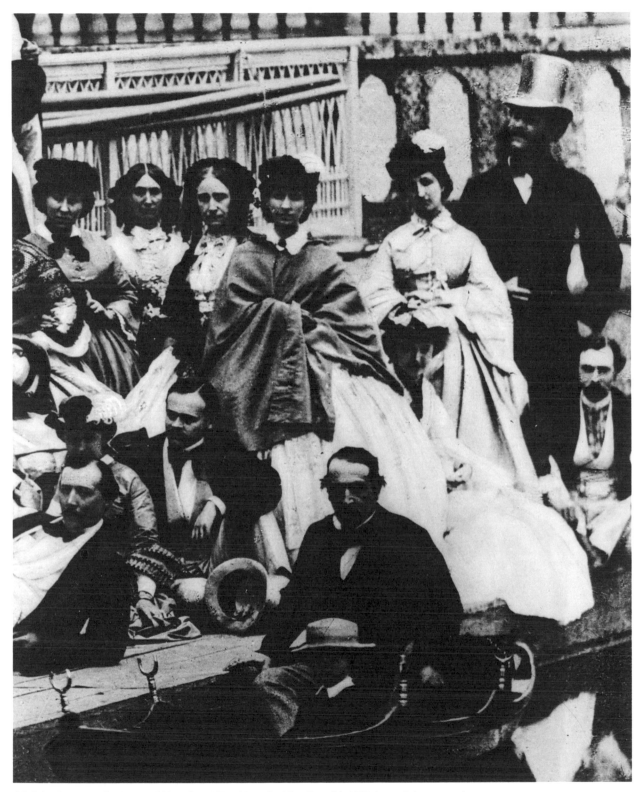

Adolphe Braun: The Court of Napoleon III at Fontainebleu June 24, 1860 (one of three parts)

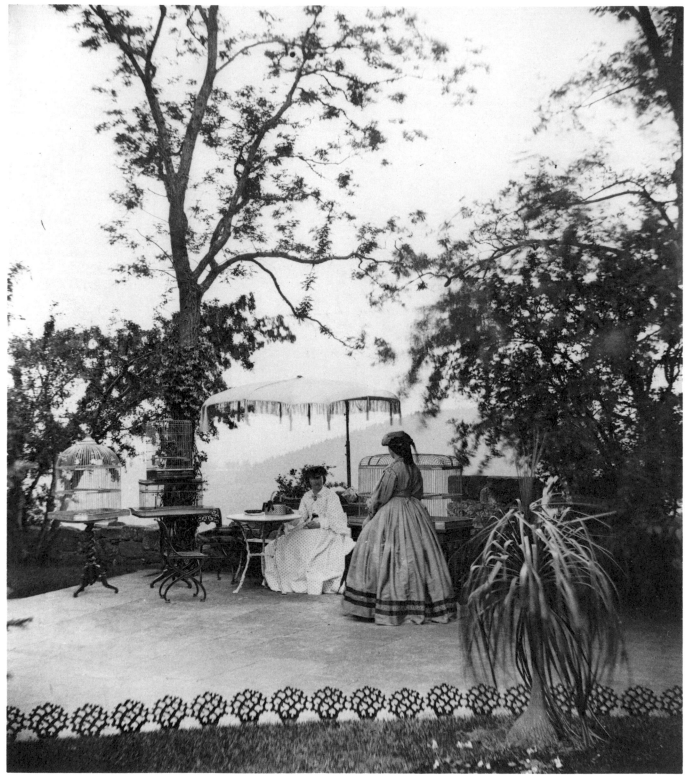

Adolphe Braun: The Garden

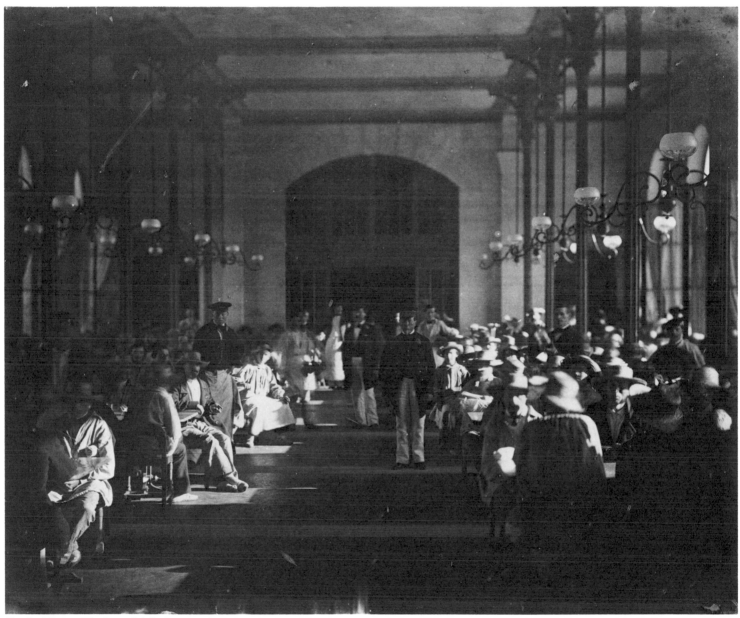

Charles Nègre: The Imperial Asylum at Vincennes 1860

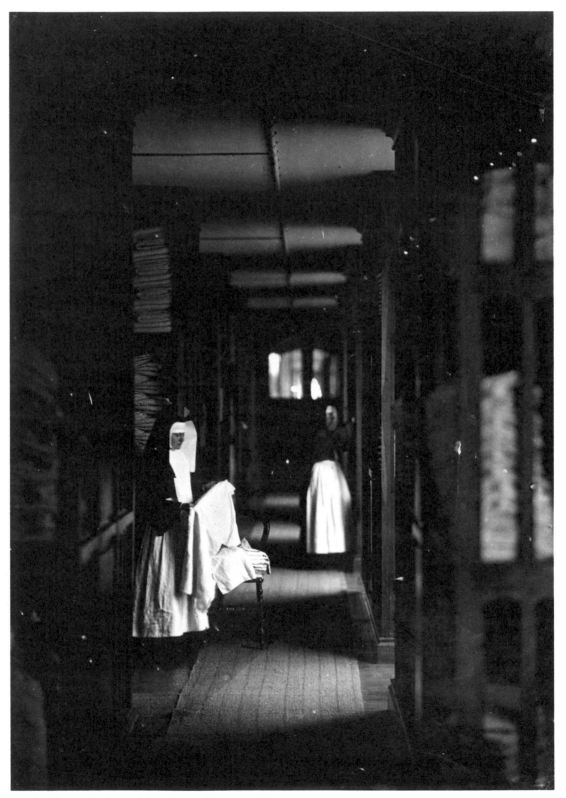

Charles Nègre: The Imperial Asylum at Vincennes 1860

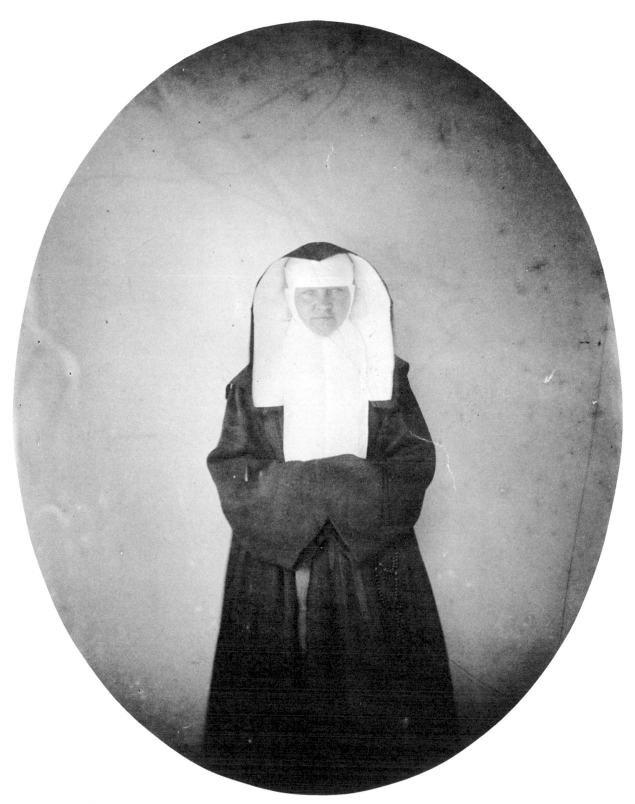

Charles Nègre: The Imperial Asylum at Vincennes 1860

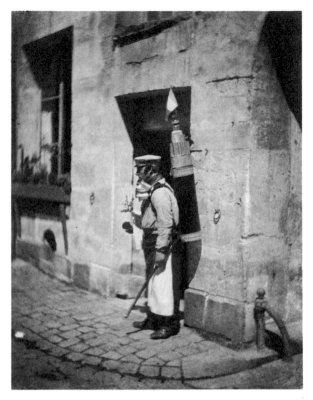

Charles Nègre: *Acquaiuolo* 1852

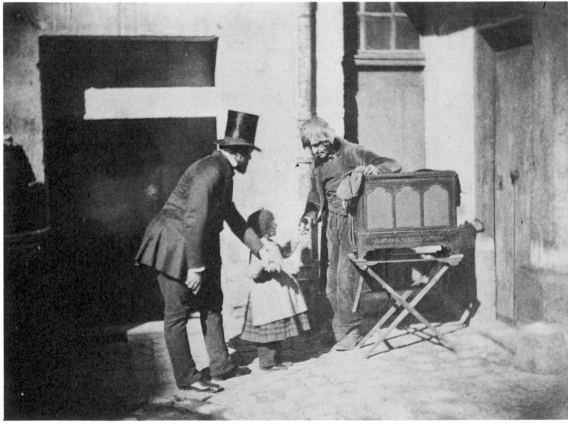

Charles Nègre: Organ Grinder 1852

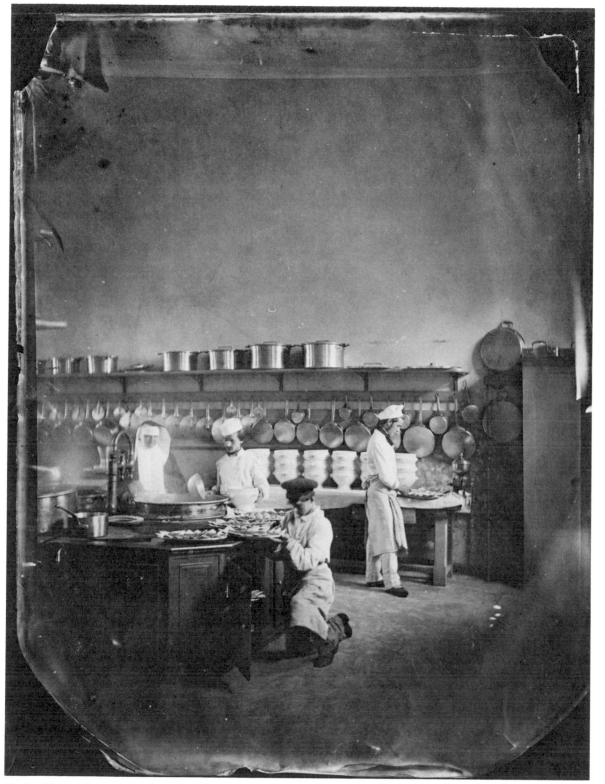

Charles Nègre: The Imperial Asylum at Vincennes 1860

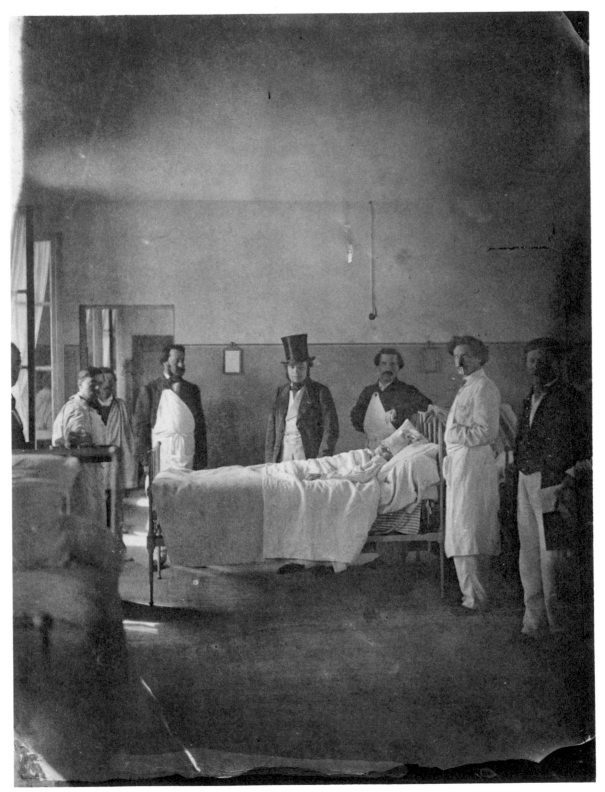

Charles Nègre: The Imperial Asylum at Vincennes 1860

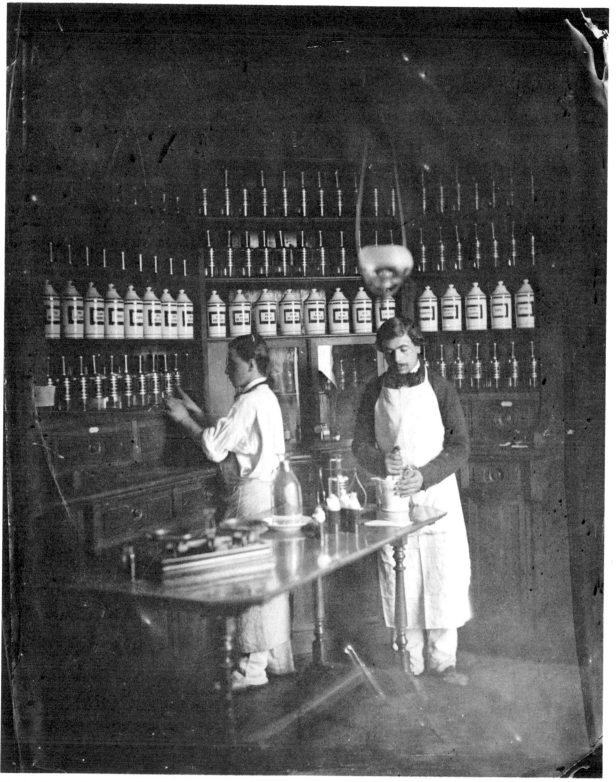

Charles Nègre: The Imperial Asylum at Vincennes 1860

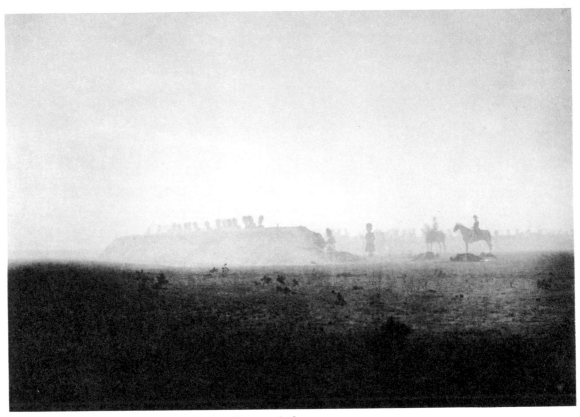

Gustave Le Gray: Camp of Châlons — the Guard entrenched

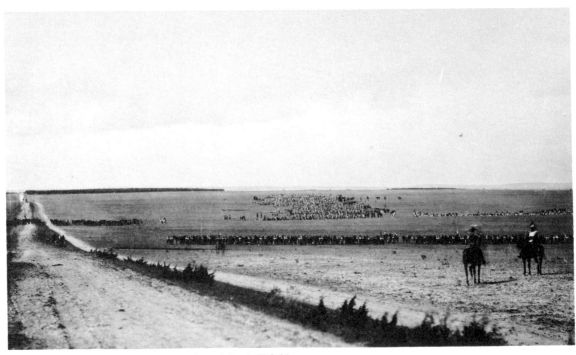

Gustave Le Gray: Camp of Châlons — view of the drill field

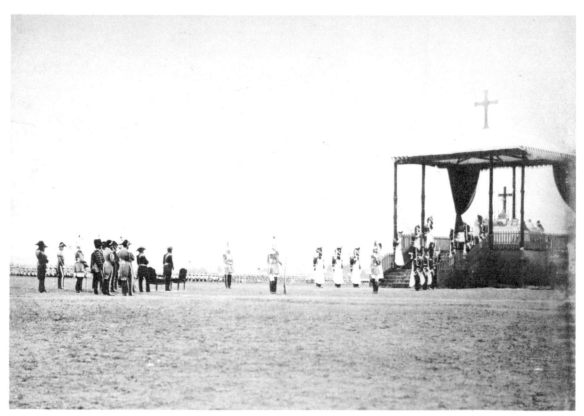

Gustave Le Gray: Camp of Châlons — mass of August 15 before the Emperor and Marshal Canrobert

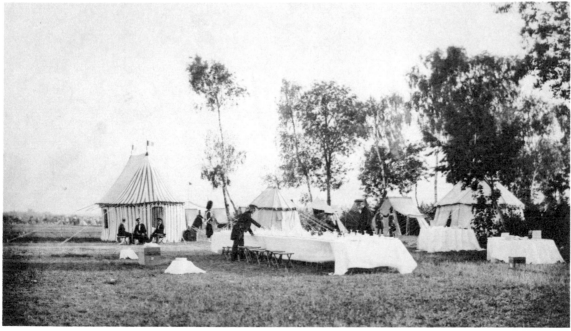

Gustave Le Gray: Camp of Châlons — the Emperor's table

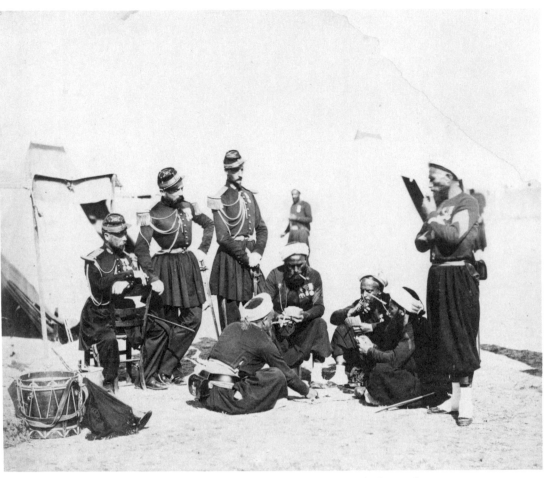

Gustave Le Gray: Camp of Châlons — Officers watching a group of zouaves playing cards

Gustave Le Gray: Camp of Châlons — the Guard at dawn 1858

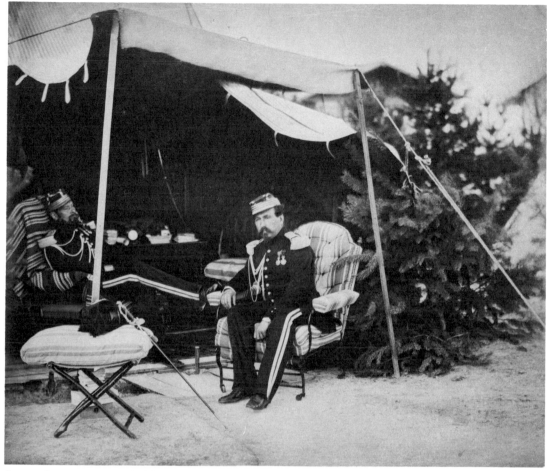

Gustave Le Gray: Camp of Châlons—officers in a tent

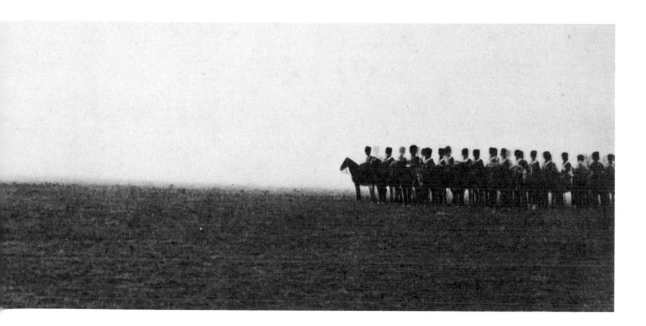

Victor Regnault: Landscape at Sèvres 1851

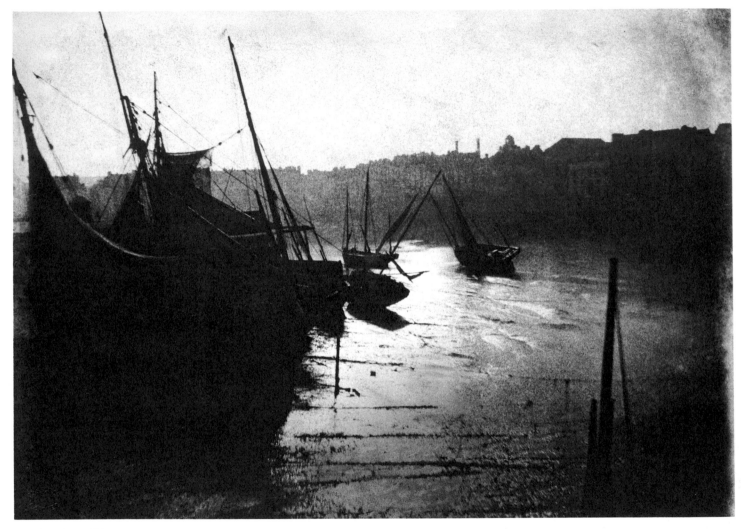

Henri Le Secq: Dieppe

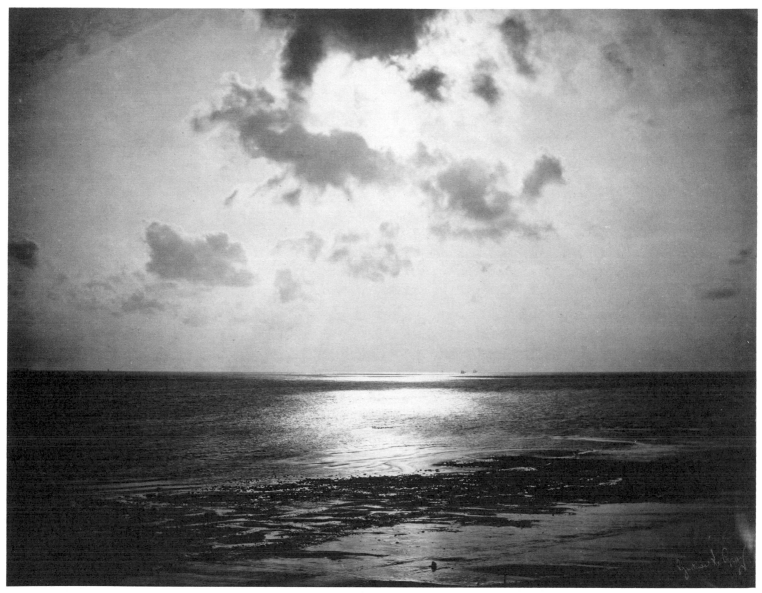

Gustave Le Gray: Seascape 1856

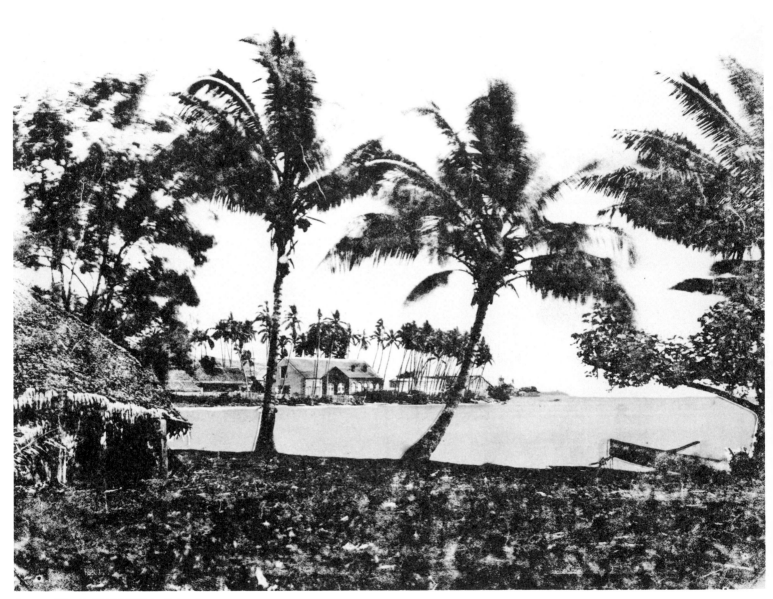

Gustave Viaud: Tahiti 1859 (collotype)

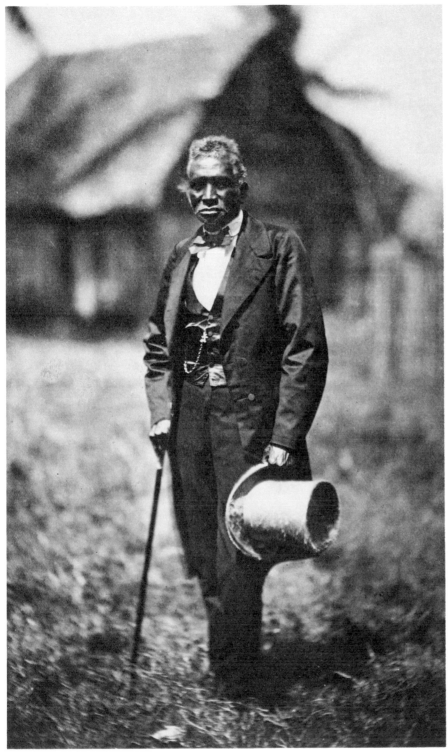

Désiré Charnay: Madagascar — The Queen's Minister

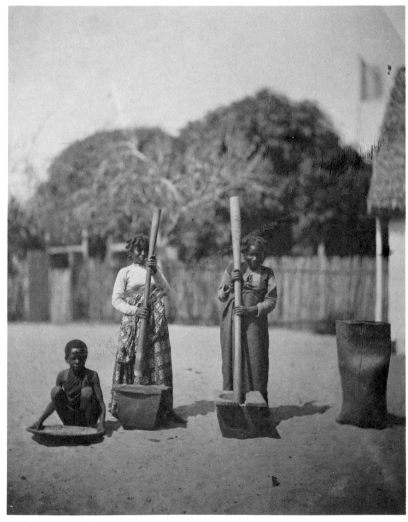

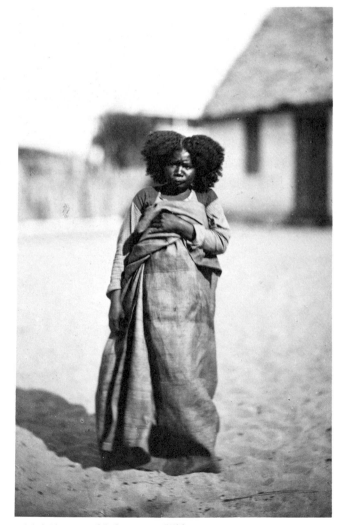

Désiré Charnay: Madagascar — Rice beaters 1863

Désiré Charnay: Madagascar — Widow

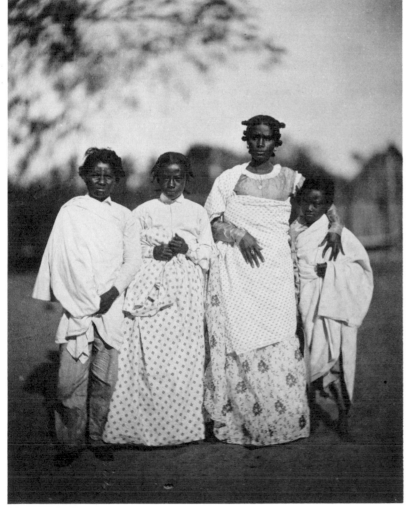

Désiré Charnay: Madagascar — Betsimisaraka women

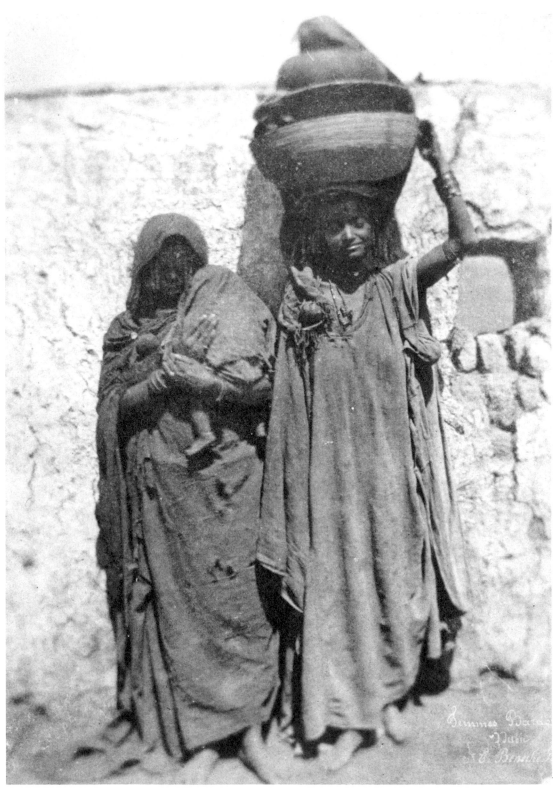

E. Benecke: From Voyage in Egypt and Nubia 1852

Louis De Clercq: Jerusalem, Seventh Station of the Cross 1859-1860

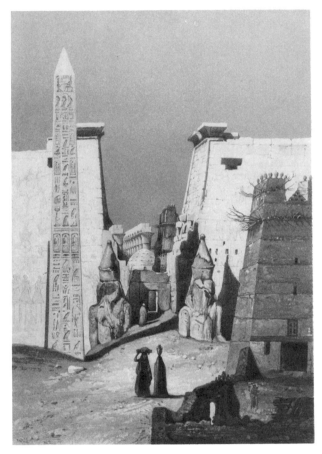

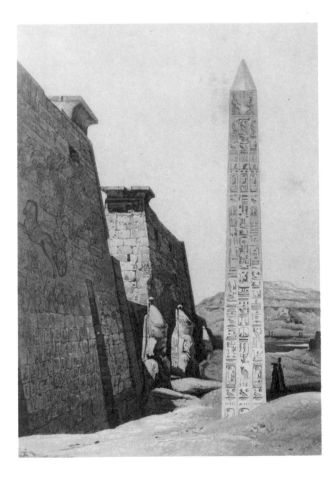

Hector Horeau: Luxor 1841 (aquatint from daguerreotype)

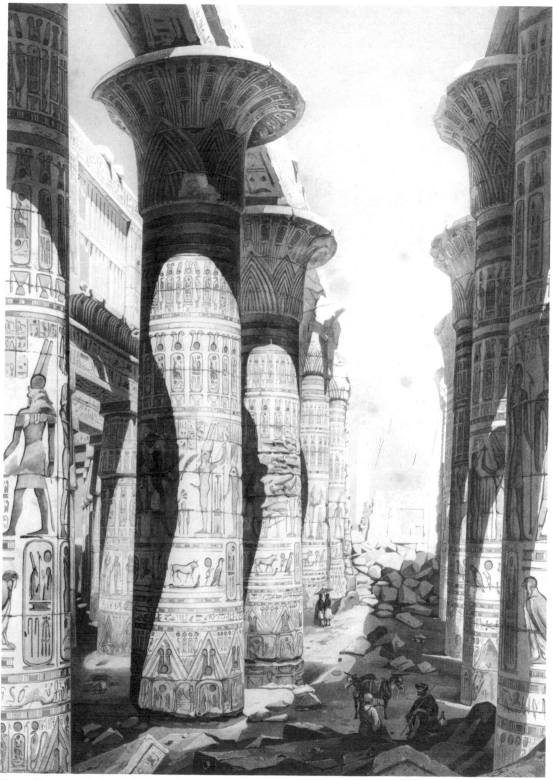

Hector Horeau: Thebes 1841 (aquatint from daguerreotype)

Charles Nègre: The Abbey of Montmajour 1852

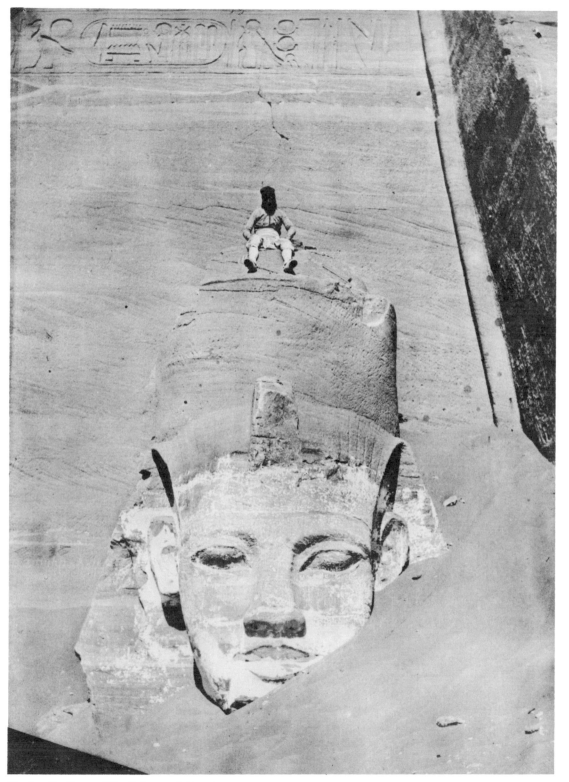

Maxime Du Camp: The Colossus of Abu Simbel 1851

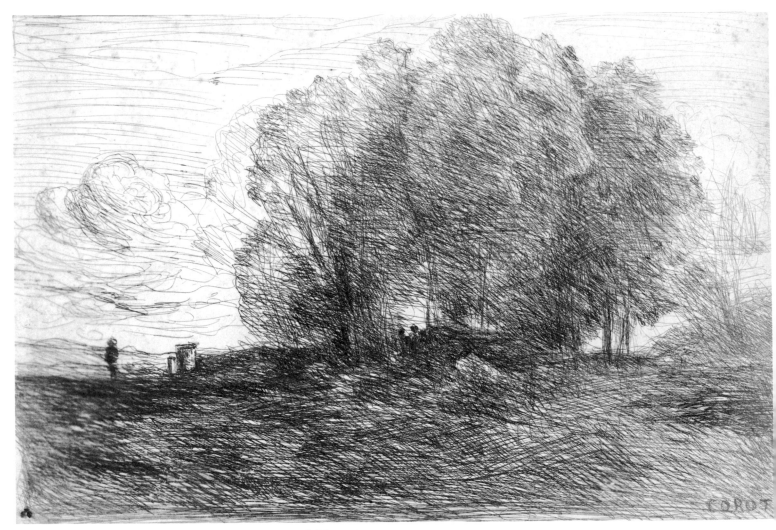

Camille-Baptiste Corot: *Le Bouquet de Belle Forière* 1858 (cliché-verre)

Jean Renaud: Path in the forest ca. 1859

Eugène Cuvelier: Grass and shrubs 1863

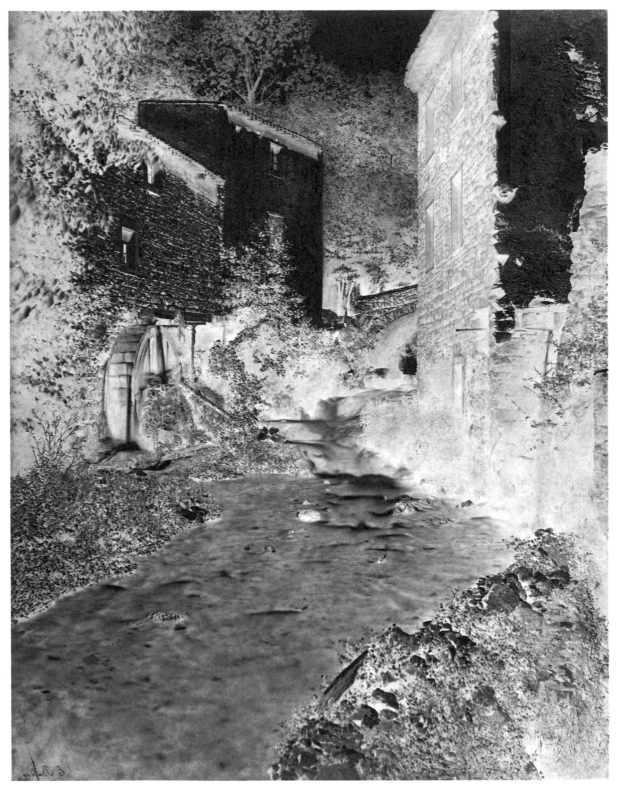

Edouard-Denis Baldus: Windmill in Auvergne 1854

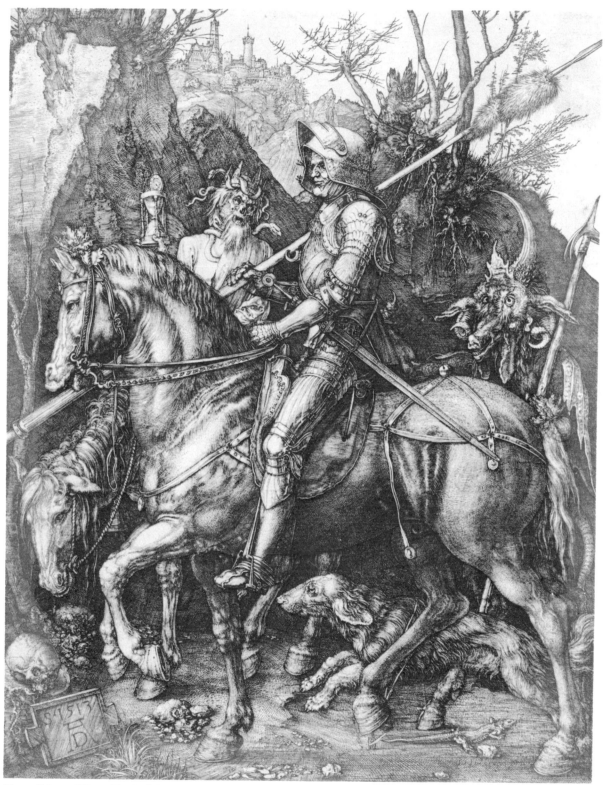

Bisson Frères: Dürer, *The Knight is Dead* 1854

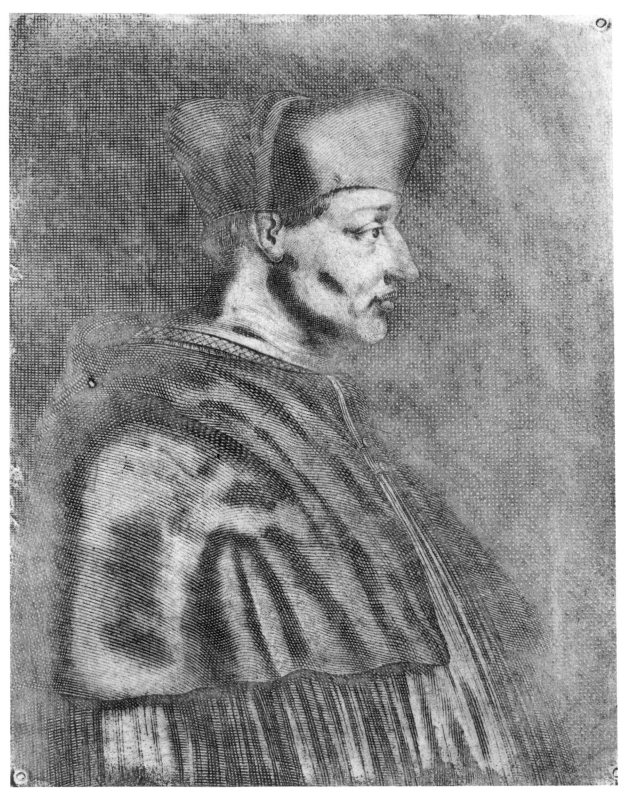

Nicéphore Niepce: Portrait of Cardinal d'Amboise 1827 (photo-etching)

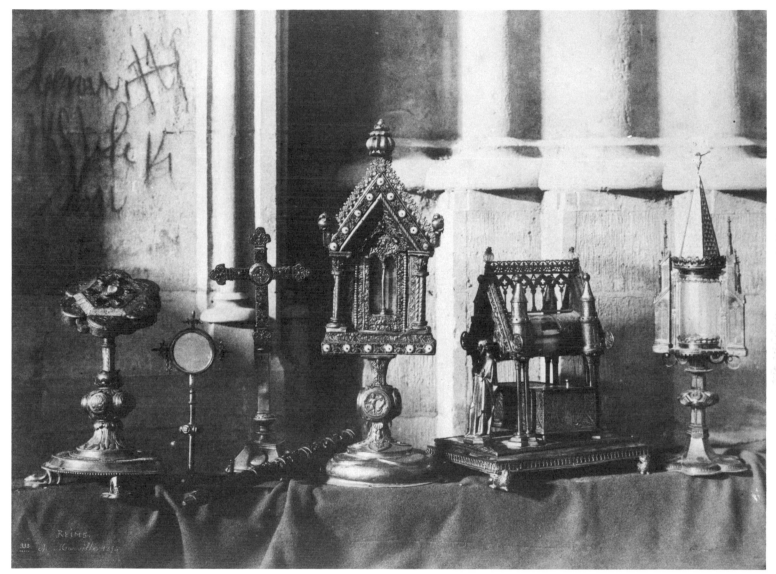

Charles Marville: Treasure of Reims Cathedral 1854

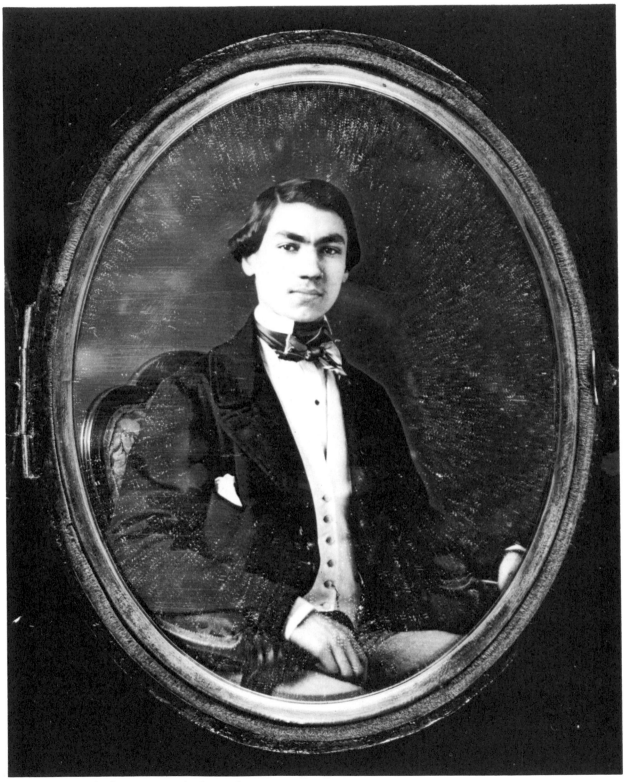

Unknown: Portrait of a young man (ambrotype)

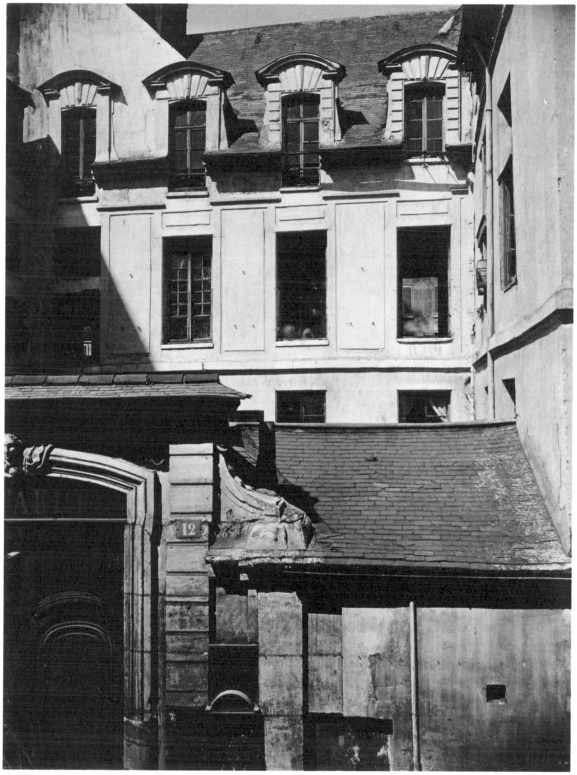

Unknown: The Town Residence of Lesdiguièrs ca. 1865

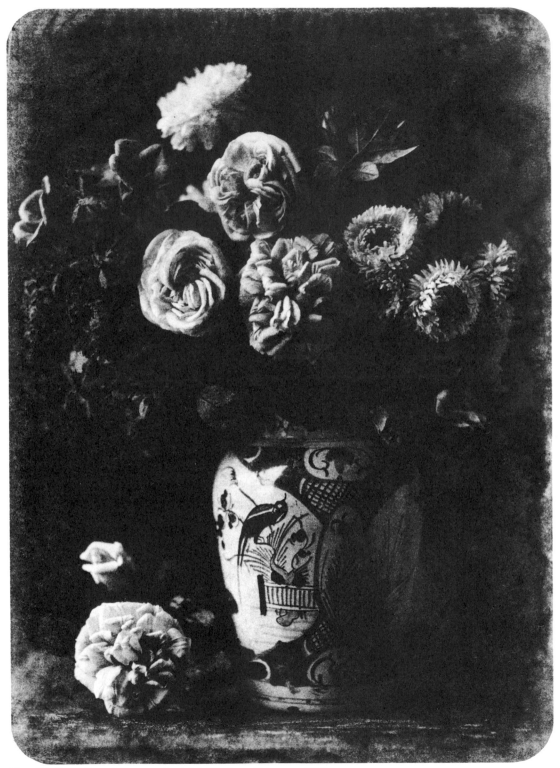

Henri Le Secq: Vase of Flowers, *Fantaisie Photographique* ca. 1856

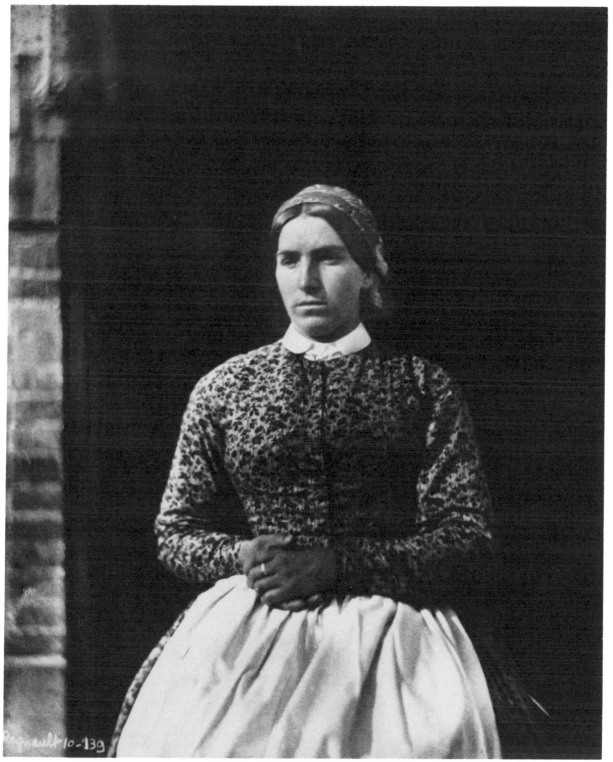

Victor Regnault: Portrait of a servant ca. 1851

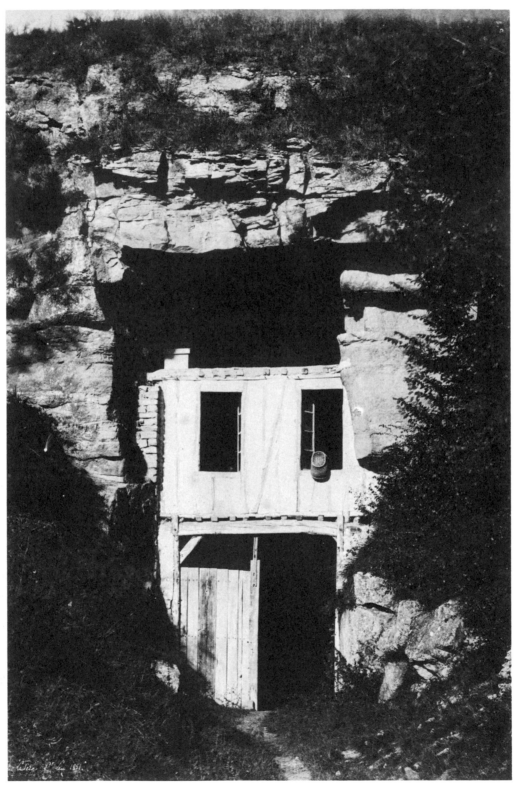

Henri Le Secq: Dwelling in the quarries of St. Leu 1851

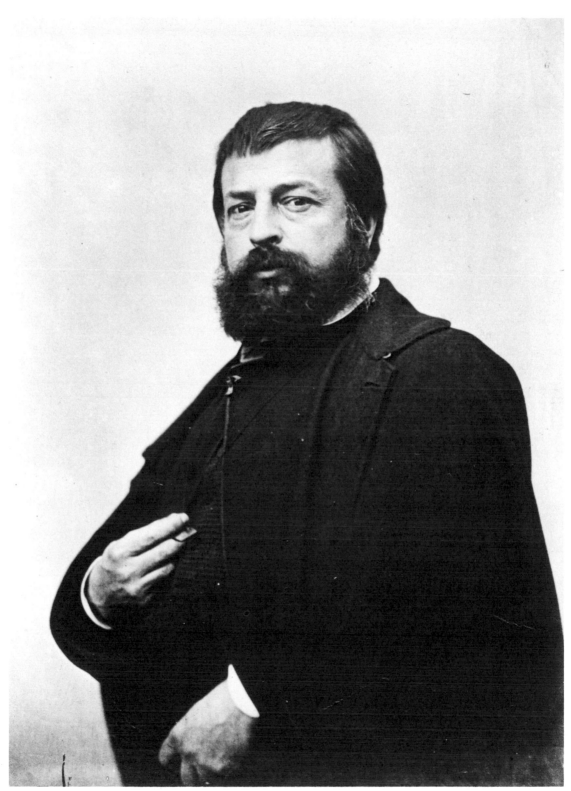

Nadar: Jean Louis Ernest Meissonnier ca. 1863

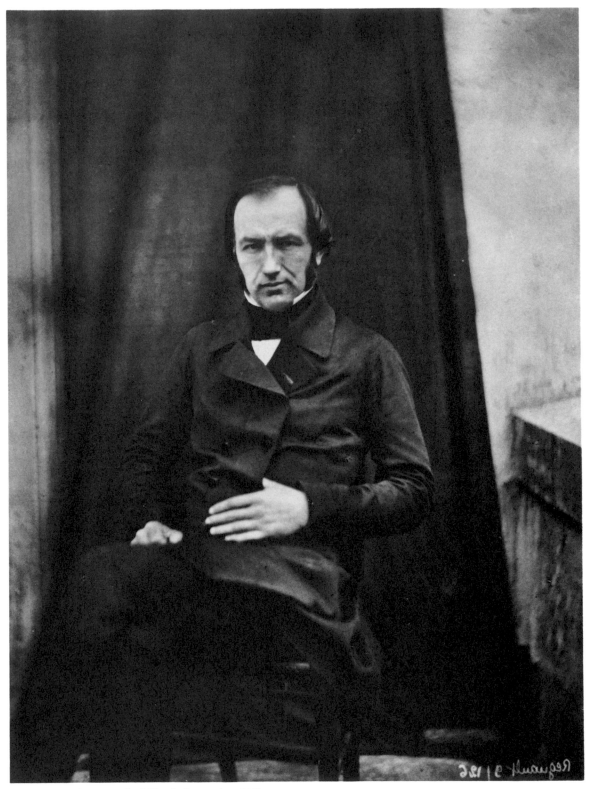

Victor Regnault: Portrait of Claude Bernard ca. 1851

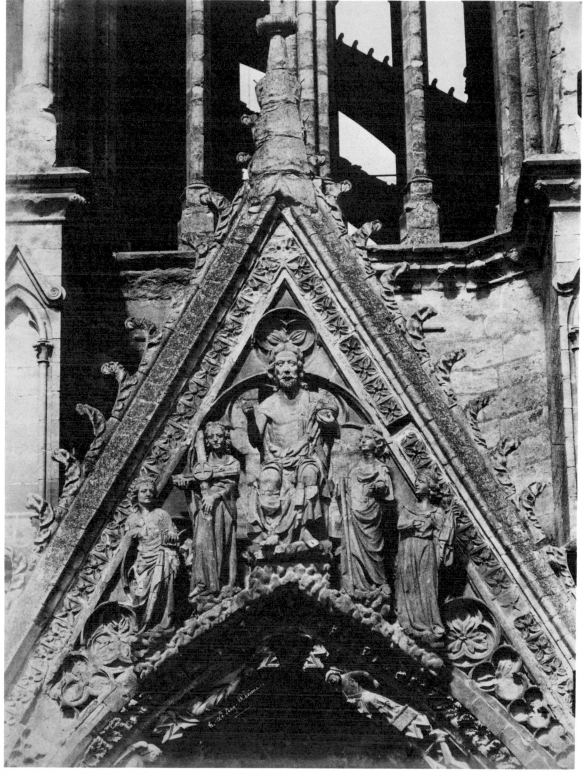

Henri Le Secq: Reims Cathedral 1851

Henri Le Secq: Garden Scene

Victor Regnault: Landscape at Sèvres 1851-1852

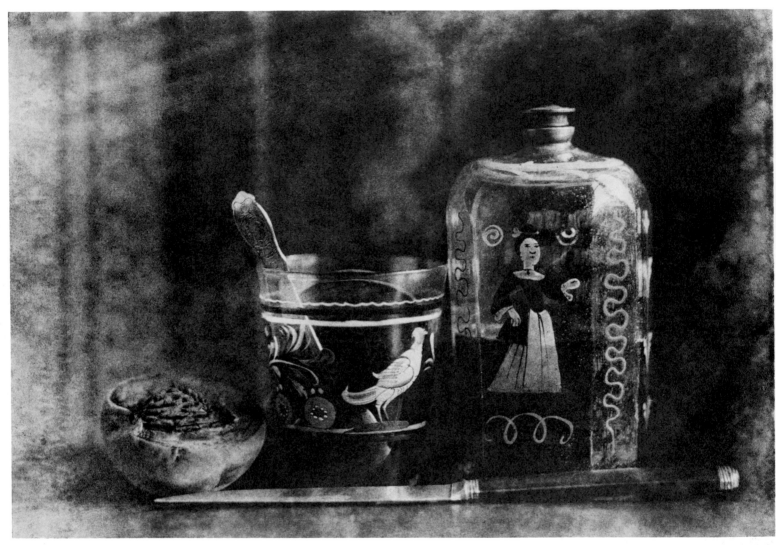

Henri Le Secq: Still Life, *Fantaisie Photographique* ca. 1856

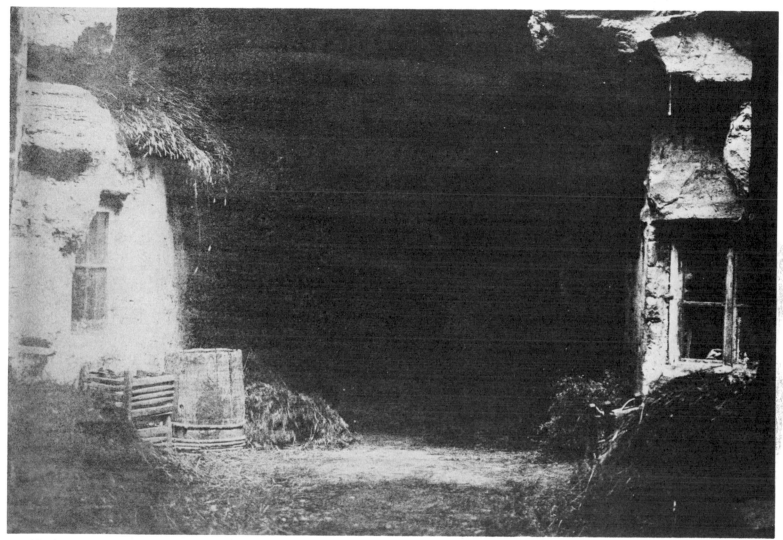

Henri Le Secq: Rustic Scene

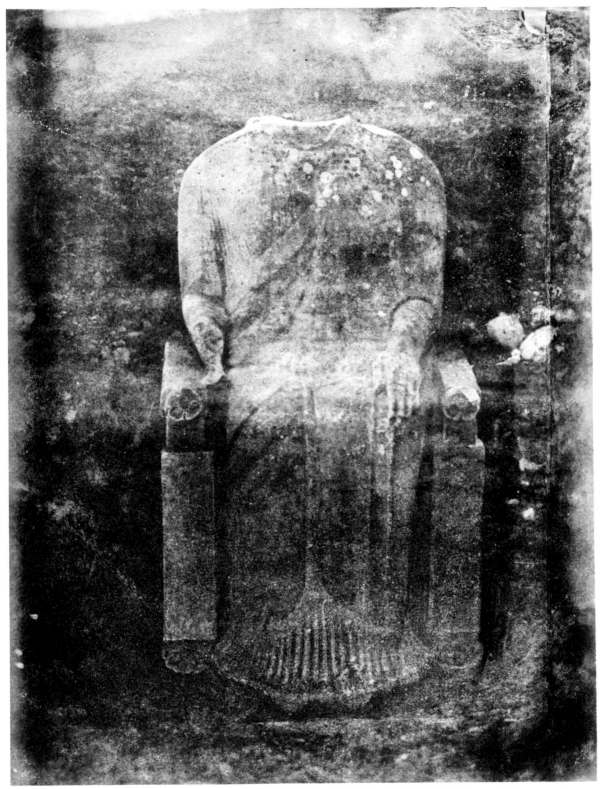

Pierre Trémaux: Asia Minor 1839

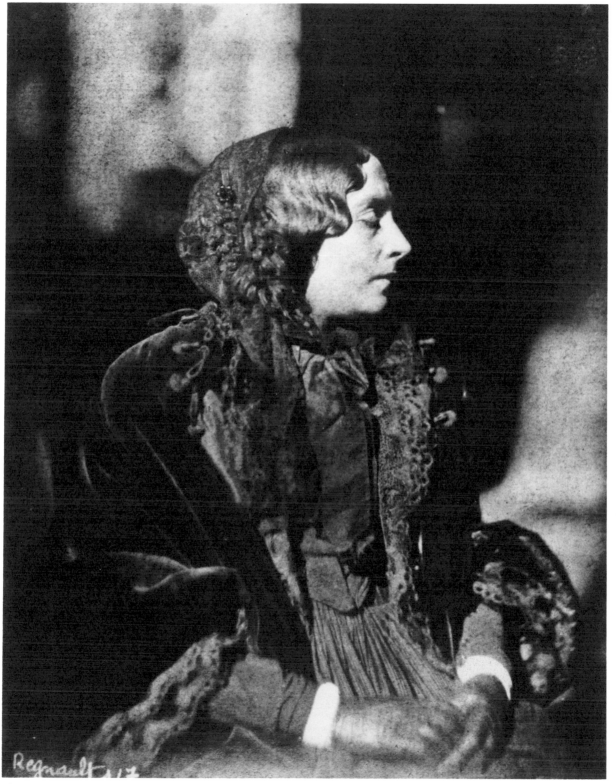

Victor Regnault: Portrait of a woman ca. 1851

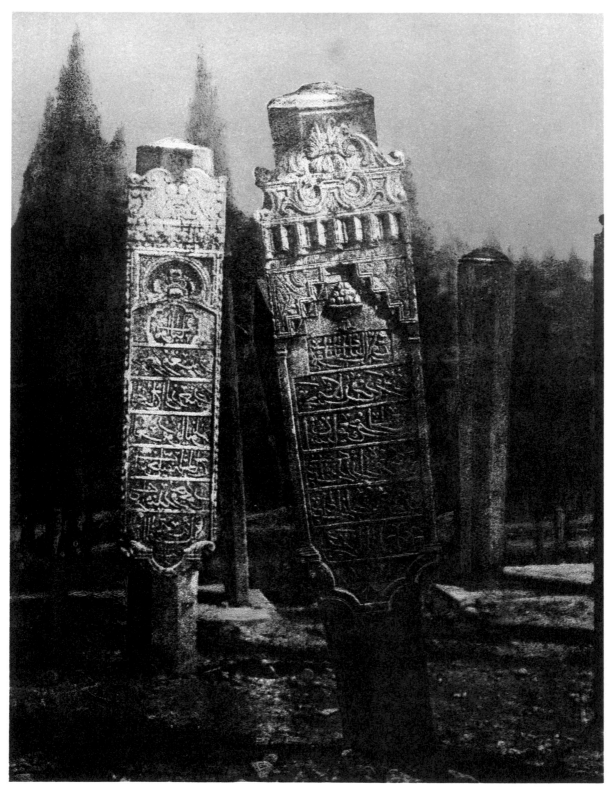

Pierre Trémaux: Turkish Stèles 1830 (photolithograph)

commentary and catalogue

French Primitive Photography

André Jammes

The unusual expression "primitive photography" requires a definition; while it is obviously easy to give a title to an exhibition, it is more difficult to justify it.

French primitive photographers flourished during a relatively brief period, roughly from 1850 to 1865 allowing exceptions for forerunners and latecomers. Theirs is an art of discovery and of pioneering. From the very first, they adapted to the new techniques at their disposal and drew out the best effects. They relied as much on instinct as on talent. These primitives were neither amateurs nor professionals; they were both, in a period when this distinction had not yet been established. Almost all were painters, and for them photography became a means of enriching their art or as a means of survival. Some rich amateurs like Le Secq became professionals, but specialists like Le Gray and Nègre returned to their brushes and easels.

The only true professionals adept at photography ever since its discovery were the daguerreotypists at whom "squalid society hurled itself, like a single Narcissus, to contemplate its vulgar image upon the metal plates," as Baudelaire so aptly put it. Later, other practitioners dealt with stereoscopy and pornography. "Shortly after the rise of photography, thousands of eager eyes were glued to the holes of the stereoscope as if gazing through the skylight to infinity. The love of obscenity, which is as active in the natural feelings of man as self-love, did not allow so splendid an occasion of satisfying itself to escape." These invectives of Baudelaire found their mark, and rightly so, but it would be too simple to classify *all* photography as the outlandish abomination he abhorred. Baudelaire never attacked nor despised the works we have brought together. The author of the *Fleurs du Mal* dedicated his famous poem "Le Voyage" to Maxime Du Camp, and "Le Rêve d'un curieux" to Nadar. He treated as fanatics "the new worshipers of the sun," yet he readily posed for Nadar, who was present at his deathbed, and for Carjat, friend of the poets and idealists.

Baudelaire and the adherents of "art for art's sake" would not concede photography the smallest wedge in the realm of pure art. They wished it kept "the very

humble servant, like printing and shorthand which have neither created nor supplanted literature." We seek to examine it in this same way—in its humility. And this is why we emphasize above all its documentary value, believing firmly that beyond plain statement photography "intrudes on the domain of the intangible and the imaginary"—which it had been denied.

These primitives then are the people Baudelaire accepted—these first skillful makers of the calotype, these archeological adventurers, these investigators of historic monuments, these scrutinizers of the human countenance—these very primitives who were to be annihilated by the manufacturers of portrait visiting cards.

Baudelaire's venom, in any case, was not aimed at Niepce's disciples until 1859. Until then early photographers enjoyed a high public esteem. Reactionism had yet to set in. Du Camp was proud of his Egyptian calotypes in 1852, although twenty years later he was ashamed of them. Saddened by the death of his son the famed historical painter, Regnault also completely disclaimed his photographic past. Flaubert deplored the Legion of Honor being bestowed on Du Camp for his photographs while poets were in exile.

Generally this was a period of grace, very brief and very complete, before new techniques toward the end of the century opened new vistas.

The Société Française de Photographie has made it possible to fill a serious gap in this exhibition by loaning several invaluable prints by Hippolyte Bayard, who in June, 1839, organized a show in Paris of photographs printed on paper. The richness of this collection reveals, for the first time, the range of Victor Regnault's talents, and future historians will doubtless place him among the top ranking founders of photography. Some visitors not in sympathy with the restrictions observed in making our choices may find gaps in the selection, but we trust that while viewing many pictures hitherto unseen they will become aware of the wealth of material still hidden away in lost boxes which, gradually unearthed, will help us to reevaluate our ideas of the history of photography.

"Exactly repeatable pictorial statements"

It is not by chance that one of the first works shown in the exhibition is the reproduction of a print by Joseph Nicéphore Niepce. This picture is one of the first experiments by the inventor of photography; it is also a symbol of the two functions of photography: the exact *recording* of reality and the exact *reproduction* of this record.

Photography was really born with Niepce; as a unique object and despite its charm, the daguerreotype should only be considered as a step in the evolution of a technical process. Photography only came to full fruition with Talbot, Blanquart-Evrard, and a few others who were finally able to secure multiple reproduction from the single negative. Except for the purpose of comparison, the daguerreotype figures in this exhibition only to the extent that it became duplicable in some form, whether manual or purely photomechanical. The documentary function of photography to which it was humiliatingly limited proved in time to be its prime asset, the very essense of its originality.

Primitive photographers were conscious of the beauty of their products, but they were hardly aware that beyond simple documentary evidence they were laying the foundations for a new language. Was the Jerusalem stonework that Salzmann reproduced Jewish, Roman, or Christian? This was fundamental, but there was also the light on the steps of a stairway, the texture of the time-ravaged walls. This secondary pictorial feature, possibly intentional, was not merely the realism that Baudelaire considered slavish but a new mode of expression intrinsic to photography. We find in this new form a delight which the primitive originators sensed only dimly.

1 Nicéphore NIEPCE. Portrait of Cardinal d'Amboise. Photoetching, 1827. Printed in 1862 from the original tin plate for J. Chevrier, Mayor of Chalon-sur-Saône, dedicated to J. Niepce de Saint-Victor, who later re-dedicated and presented it to Ernest Lacan, Editor-in-Chief of the publication *La Lumière.* 162x130*

Strictly speaking, Niepce's first successful efforts do not concern photography but rather photomechanical processes.

The original seventeenth-century print had been made transparent by the use of melted wax. Niepce then put it in contact with the tin plate smeared with bitumen of Judea. After exposure to the sun the bitumen hardened in places where the sun had penetrated the print. Acid then etched the parts that had been dark in the print, thus reproducing an etching close to the original. (N.B.: the date, 1824, given by Chevrier in his dedication is incorrect.)

2 Hippolyte BAYARD. Nature printing: feathers, material, print, about 1839-1842. (Collection of the Société Française de Photographie.) 245x208

This negative print may date from Bayard's first experiments, early in 1839, or after the reports of Talbot's work. The picture was produced simply by exposing the sensitized paper, on which rested the objects themselves, to the sun.

3-4 Hippolyte BAYARD. Two still lifes: collection of casts, about 1839-1840. Direct positive prints. (Collection of the Société Française de Photographie.) 161x174, 138x210

Bayard sensitized a sheet of paper in silver nitrate, allowing it to darken in the light. He then resensitized the paper in potassium iodide just before using it. In the darkroom a complex inversion took place; the picture became positive. As a unique object, like the daguerreotype, the picture could not be reproduced, nor did it have the splendid sharpness of the daguerreotype. Bayard arranged an exhibition of some thirty of his pictures June 24, 1839, about a month before the techniques of Niepce and Daguerre were revealed during a sitting of the Academy. This was the first exhibition of photographs in the world.

5 Hippolyte BAYARD. Still life: collection of casts, June, 1840. Direct positive print (?) . (Collection of the Société Française de Photographie.) 256x304

6 Benjamin DELESSERT. Reproduction of the "Holy Family" of Marcantonio Raimondi, about 1852. Positive print by Blanquart-Evrard from the negative on paper. 238x167

This is the first example of the reproduction of an artist's complete works through photography. From 1854 on, Delessert was to use the photoetching process of Niepce de Saint-Victor, thus coming closer to the quality of the original.

7 BISSON frères. Ecce Homo. *L'Oeuvre de Rembrandt reproduit par la photographie, décrit de commenté par M. Charles Blanc.* Printed by Lemercier from negative on glass, 1854-1858. 424x353

This was the first album published by the brothers Louis-Auguste and Auguste-Rosalie Bisson. It was followed by numerous publications on art, architecture, and science.

8 BISSON frères. The Knight, Devil and Death. *Oeuvre d'Albert Dürer*

*Sizes are in centimeters

photographié. Positive prints from glass negatives, 1854. 245x187

9 Louis-Désiré-Joseph BLAN-QUART-EVRARD. St. Ursula and Her Companions Painted by Memling Plate 32: *Album photographique de l'artiste et de l'amateur,* 1851. 202 x133

The lack of sensitivity to certain colors of the early emulsions greatly impaired the reproduction of paintings. This example is from the first collection of photographs published in Lille by Blanquart-Evrard, who from 1851 to 1855 operated a veritable small factory of assembly line prints. Besides large travel volumes ordered by Paris publishers, the establishment in Lille produced numbers of albums: among them were *L'Art religieux, L'Art contemporain, La Belgique, Dessins originaux, Gravures célèbres,* and *Etudes photographiques.* Almost all of these have disappeared.

The appearance of these faithful reproductions of works of art must be considered an influential event in France. Published only four years after the *Annals of the Artists of Spain* by William Sterling, these reproductions are of a quality highly superior to those produced by Talbot. To quote William Ivins, they were "the first exactly repeatable pictorial statements about works of art which could be accepted as visual evidence about things other than mere iconography. It was no longer necessary to put faith in the accuracy of the observation and skill of the draughtsmen and the engravers. These reports were not only impersonal but they reached down into the personality of the artists who made the objects that were reproduced."

10 Charles MARVILLE. Treasure of

Reims Cathedral. Positive print from paper negative, 1854. 252x345

11 Charles MARVILLE. Statue of Diana by Jean Goujon, Louvre Museum. Blanquart-Evrard print from paper negative, about 1851-1855. 350x250

This photograph is the seventh in *Paris Photographique* by Blanquart-Evrard, one of the most beautiful of the Lille publications. The album should contain thirty-five pictures, but there is no known complete set extant.

Excursions daguerriennes. Vues et monuments les plus remarquables du globe. Paris, Lerebours, 1842-1844.

12 The Alhambra. Aquatint by Salathé from a daguerreotype. 150x205

13 Bas-relief from Notre Dame. Executed by the Fizeau process. 175x138

Daguerreotypes made from 1839 fascinated artists the world over, but their effect would have been very limited if means had not been found to disseminate the image.

After 1842, the optician Lerebours engaged engravers of extraordinary skill who succeeded in faithfully duplicating daguerreotypes. Soon Fizeau, who was only twenty-two years old, managed to convert them into printable engraved plates without manual intervention.

Excursions daguerriennes form a remarkably faithful catalogue of architecture in which certain pictures achieve complete authenticity.

14 Hippolyte FIZEAU. The Cathedral of Notre Dame. Daguerreotype converted into a copperplate engraving, 1842. 190x145

This south side of the Cathedral is perhaps a plate rejected by Lerebours. It is the oldest extant photograph of

this building, and the only known proof. It shows the old sacristy built by Soufflot, which was torn down shortly after the picture was taken. Fizeau patented his process September 12, 1843.

15 Hippolyte FIZEAU. Notre Dame, south porch. Daguerreotype converted into a copperplate engraving, 1842. 170x135

16 Hippolyte BAYARD. Old house being restored, about 1848 (?). Print made in 1965 from the original wax paper negative. 231x174

The daguerreotype was a dead end in photography. By inventing a method to obtain direct positives on paper in 1839, Bayard had really achieved little. However, after 1842, he adopted Talbot's negative-positive system and became one of the first in France to achieve splendid calotypes rivaling England's best products. Bayard also indubitably outdistanced his predecessors in the search for aesthetic qualities. Moving beyond traditional pictorialism, a feeling for the purely photographic image dawns in his work. It is difficult to pinpoint what he was aiming at in this composition, though he was certainly a forerunner of "the direct approach." Beyond documentation, henceforth "exactly repeatable," appears straight photography.

17 Louis-Désiré-Joseph BLAN-QUART-EVRARD. The Marketplace at Ypres. Positive from paper negative, 1846 170x216

A number of proofs by Blanquart-Evrard dated 1846 or 1847 are known. They mark a period when the Lille photographer had finally mastered and perfected the calotype.

After 1844, Blanquart-Evrard used Talbot's method, learning from a phar-

macist named Tanner. He soon perfected and simplified the process, adding a certainty to the results that Talbot's technique lacked.

His negative paper was thoroughly soaked in a solution of potassium iodide and silver nitrate. Development was brought about by the use of gallic acid.

The precision of his method, its simplicity and reduced exposure time, encouraged him to send a paper with a description of the process and trial proofs to the Academy of Sciences in January, 1847.

In April of the same year, he gave demonstrations which were considered conclusive for Regnault, Biot, and their pupils. This official stamp of approval for photography on paper led many photographers to abandon the daguerreotype in favor of the new methods.

18 Eugène PIOT. The Acropolis: The Parthenon. Positive proofs from paper negatives, 1852. Interior elevation (northeast angle). 330x227

Eugène Piot, archeologist, art critic, and collector, was the first French scholar to use the calotype in research and for reproduction. He made a great number of negatives during his travels in Italy, Sicily, and Greece. The first installment of his *Italie monumentale* appeared several months before Blanquart-Evrard's first album and new editions appeared for several years, at least until 1857. To date, unfortunately, not one copy is to be found. His library catalogue (2nd Sale, 1891, No. 3637) describes the following illustrations: *"Temples grecs*. 2 pl., *L'Acropole d'Athènes*, 109 pl., *L'Italie monumentale*, 255 pl., *L'Elite des monuments français*, 23 pl."

Henri LE SECQ. Reims Cathedral.

Positive proofs from paper negatives, 1851.

19 Details of the portal (right gable, west façade). 335x250

20 "Tower of the Kings" (east side of the south tower). 335x250

"The young artist has recorded, stone by stone, the cathedrals of Strasbourg and Reims in over a hundred different prints. Thanks to him we have climed all the steeples...what we never could have discovered through our own eyes, he has seen for us... one might think the saintly artists of the Middle Ages had foreseen the daguerreotype in placing on high their statues and stone carvings where birds alone circling the spires could marvel at their detail and perfection....The entire cathedral is reconstructed, layer on layer, in wonderful effects of sunlight, shadow, and rain. M. Le Secq, too, has built his monument." (H. de Lacretelle, in *La Lumière,* March 20, 1852.)

This photographic documentation was part of a vast inventory study of France's ancient monuments, undertaken by the Commission of Historic Monuments and initiated by Baron Taylor and Mérimée. Baldus, Bayard, Le Secq, Mestral, Le Gray took part in this project. The itineraries of the five "missions" are known. Of hundreds of negatives taken throughout France, many are preserved in the photography office of the "Direction de l'Architecture" in Paris. The Musée des Arts Décoratifs also owns 253 negatives by Le Secq.

21 Henri LE SECQ. Sculpture from Chartres Cathedral. A positive proof from a wax paper negative, 1852. 335 x250

22 Henri LE SECQ. The Pont-Neuf

in Paris. Positive print from a paper negative, 1852. 335x250

This photograph was taken before the restorations, bearing the hand notation, "Souvenir of the old Pont-Neuf."

23 Gustave LE GRAY and MESTRAL. Blois: The great staircase of the château. Positive proof from a wax paper negative, 1851. 370x292

This print bears the seal of Le Gray although the negative in the collection of the Société Française de Photographie is signed by Mestral. Both men collaborated in a trip undertaken at the request of the government Commission of Historic Monuments.

Charles NEGRE. *Le Midi de la France.* Positive prints from wax paper negatives, 1852.

Charles Nègre, painter, pupil of Ingres and Delaroche, began photographing in 1851. His friend Le Secq was his adviser, and Le Gray his teacher. Born in Grasse, he specialized in recording his native province, leaving some sixty photographs of great quality. Heartened by the success of Maxime Du Camp, whose 125 Egyptian pictures sold well, he launched a subscription series with the publisher Goupil. The project proved a total failure. Only the first installment appeared and a few plates sold; no complete set was ever printed.

24 Arles, Saint Honorat. 337x432

25 Abbey of Montmajour 295x224

26 Arles, Gate of Chestnuts. 227x316

Charles NEGRE. Chartres Cathedral, north side, 1854.

27 Paper negative. 740x537

28 Positive print. 732x510

These very large photographs were

probably taken in the summer of 1854 and exhibited by the Société Française de Photographie in 1855. Nègre had to use a camera of corresponding size, and he very likely had one especially built. Perspective exaggerations are almost non-existent, which is a real feat. The negatives shown here are perhaps the largest known of that period.

29 Charles NEGRE. Chartres Cathedral, south tower. Negative on wax paper, 1854. 740x533

Charles NEGRE. Chartres Cathedral, south porch. Positive proofs from albumen negatives on glass, 1854.

30 General view. 516x709

31 Detail from the central portal. 724x530

Niepce de Saint-Victor had perfected a formula on glass, using white of egg with silver salts. Nègre used this method to obtain grainless prints intended for reproduction by photogravure.

Charles NEGRE. Chartres Cathedral, statue-columns.

32 Positive print from albumen negative on glass, 1854. 615x465

33 The same photograph reproduced by photogravure, 1855. 726x482

Charles Nègre studied all methods of reproduction possible in his time, but he was most successful with the hand photogravure processes which he raised to heights difficult to surpass even today.

34 Charles NEGRE. The Pavillon de L'Horloge at the Louvre. Positive print from an albumen negative on glass, about 1855. 700x521

This was a classic theme of the period, when the Louvre was the object of numerous restorations. Charles Nègre set out to rival Baldus, who received wide recognition for the perfection of a similar picture.

35 Charles MARVILLE. Chartres Cathedral. Large figures from the Royal Portal. Positive print by Blanquart-Evrard from a paper negative, about 1851-1855. 337x239

"Marville, still a painter," said Nadar. We are indebted to him for several lovely calotypes, a process he soon abandoned in favor of collodion prints.

36 Edouard-Denis BALDUS. Place de la Concorde, Paris. Negative on wax paper, about 1852-1855. 340x440

Baldus was also a painter. He had photographed Normandy for the government (1851), Auvergne, and Provence (from 1852 to 1855). He used the wax paper method with unequalled dexterity. His negatives are transparent and almost devoid of grain.

37 Edouard-Denis BALDUS. The St. Jacques Tower in Paris. Positive print from paper negative, about 1854. 432x343

In this unusual view the tower's base had recently been freed of the houses which disfigured it. Unfortunate restorations have not yet been made.

38 Louis ROBERT. Fountain in the Park of Saint-Cloud, about 1851-1855. 320x255

Louis Robert was the chief painter at the Sèvres porcelain factory. He took a fine series of architectural views in Versailles and Saint-Cloud, certain of which were published by Blanquart-Evrard. His director, Victor Regnault, undertook similar projects. Through its combined aesthetic and industrial character the making of porcelain was clearly a milieu favorable to the development of photography.

Auguste SALZMANN. Jerusalem. Positives by Blanquart-Evrard from paper negatives, 1856.

In 1854, A. Salzmann, the archeologist and photographer, undertook a trip to the Holy Land, hoping to confirm historical theories promulgated by de Saulcy, a member of the French Institute. Hypotheses put forth by the famous archeologist relative to the dating of certain monuments were supported only by drawings and sketches considered dubious. On the other hand, the evidence submitted by Salzmann was immediately accepted. He wrote in his preface: "Photographs are more than tales, they are facts endowed with convincing brute force." Three copies of this work containing a total of 174 plates on Judaic, Arabic, and Christian monuments are known to exist.

39 Temple enclosure. Detail of the probationary pool. 226x320

40 Valley of Josaphat, Absalom's Tomb. 324x235

41 Ancient stairway carved into the rock. 333x237

42 Judaic sarcophagus. 233x327

43-45 The Holy Sepulchre. 332x237, 232x326, 325x235

46 Arabic fountain. 330x234

Documentary photography rarely melds precision of detail and beauty of execution. The first picture is a notable example of the merits of photographic evidence. In this photograph Salzmann provides information about the construction of the pool: the wall of the Temple covered with stones sometimes inserted between the blocks, then a layer of pebbles bound by mortar, and overall, a smooth coating of waterproof mortar. No drawing could have rendered these details in

which the very texture of the materials is of conclusive value.

Charles MARVILLE. Paris streets. Positive prints from collodion negatives, about 1865.

47 Rue du Gindre at the corner of rue de Mézières. 342x259

48 Rue des Marmousets at the corner of rue St. Landry. 325x266

Marville loved the picturesque and knew how to lend dignity to sordid old streets. With feeling he recorded the old Paris quarters that Haussmann pitilessly tore down. Deliberately, he chose rainy days when cobblestones glistened and the light was evenly distributed.

49 Charles MARVILLE. City Hall, Paris, inside staircase. Positive print from a glass collodion negative, about 1860. 269x369

Marville achieved documentary perfection: precise rendition of materials, perfect focus, exact perspective, luminous shadows.

50 A. FERRIER. Grande Chartreuse Monastery. Positive print published by Bingham from a glass albumen negative, April 1, 1865. 252x317

Ferrier, a prominent member of the Société Française de Photographie, perfected the albumen process, producing prints of unequalled sharpness, density, and luminosity.

51 Unknown. The town residence of Lesdiguières. Positive print from collodion negative, about 1865. 280x208

52 Edouard-Denis BALDUS. Avignon, floods of 1865. Positive print from paper negative. 320x443

From June 6 to 14, Baldus covered the flooded areas of the South of France. Officially commissioned by the government, he brought back a report in twenty-five pictures, acclaimed at the time for their artistic merit and their authenticity: "while one could suspect exaggeration in accounts written under the tragic impact of the moment, there is one testimony beyond question: that of photography—and this is of heart-rending eloquence."

Charles NEGRE. The Imperial Asylum at Vincennes. Positive prints from collodion negatives, 1860.

53 Salute to the Emperor; enlargement. 324x440

54 Mother Superior. 250x165

55 The Refectory. 340x425

56 The Kitchens. 228x170

57 The Linen Room; enlargement. 370x260

58 The Dispensary. 225x175

59 The Doctor's Visit. 215x165

Napoleon III had founded a charitable institution for the care of disabled workmen. In 1860, Nègre was given an order for a "monographie photographique" on this hospital, in short, a journalistic report. Despite difficulties due to poor lighting, he obtained good pictures by using a relatively wide lens and small plates.

Colonel Charles LANGLOIS. Photographs of the Crimean War. Positives printed by Martens from paper negatives, November, 1855.

60 The Gervais Battery. 259x318

61 The Korniloff Battery. 253x316

62 The Malakoff Tower. 225x318

Fenton's and Robertson's accounts of the Crimean War are famous; Langlois's is practically unknown. Like Daguerre, Langlois was a panoramist, but he was in the pay of the Empire's official propaganda channels.

He arrived November 13, 1855, at just the right time. It took all the authority of this photographer-colonel to prevent the destruction of the traces of war. (The Malakoff tower had been seized September 8.)

As a veteran of Wagram and as a defender of the last stands at Waterloo, his mission was practically official. Proprietor of an enormous "Panorama," he offered the Parisian public, views of French army conquests and victories on a truly "wide angle screen" of 360°. He had made a trip to Algeria in 1830 for his panorama "The Fall of Algiers"; the Navy Department had ordered from him the "Battle of Navarin"; and the Minister of the Interior had commissioned "The Crossing of the Linth." The "Panorama of Sebastopol" was painted on a circular canvas with a 105 foot diameter.

Gustave LE GRAY. Scenes of military life in the camp of Châlons. Positive plates printed from collodion negatives, 1858.

63 The Guard at dawn. 265x323

64 The Guard entrenched. 271x360

65 View of the drill field. 284x338

66 Officers in a tent. 312x364

67 Officers watching a group of zouaves playing cards. 312x364

68 The Emperor's table. 288x353

69 Mass of August 15, before the Emperor and Marshal Canrobert. 269x369

In studying these pictures it is impossible not to think of Fenton. But Le Gray, unlike the English reporter, was not working under attack, and his photographs of soldiers at drill in the early morning dust have a charm which his rival could not achieve.

70 Victor REGNAULT. Portrait of a man seated by a vacuum pump. Mod-

ern print from a wax paper negative printed by Jean-Pierre Sudre, about 1851. 180x150

Regnault had succeeded in consistently sensitizing negatives by placing the receptacle containing the paper and the silver salts solution under a vacuum dome. He urged the use of this method even while traveling.

71 Victor REGNAULT. Acoustical experiments. Modern positive print from original wax paper negative, about 1851. (Collection of the Société Française de Photographie.) 176x139

Regnault suggested a new technique for scientific drawings: he photographed the experiment, drew the contours in China ink, and then submerged the drawing in a cyanide solu-

tion which earased the photographic parts of the image, leaving only the drawing.

72 Victor REGNAULT. Acoustical experiment. Modern print from a wax paper negative, about 1851. 189x145

73 Victor REGNAULT. Laboratory instruments in the Collège de France. Modern print from the original wax paper negative, about 1851. 164x222

Conflicting Aspects of a New Art

The attitude of painters toward photographers fluctuated between contemptuous jealousy and more or less benevolent patronage. The painter-photographers returned the scorn of their critics, bristling with an arrogant aggressiveness nourished by the refusals of society to accept them on the same level as the painter. Many had their feet in both camps, though the primitive photographers avoided the extremes.

Primitive photographers challenged their rivals on an ill-chosen field, that of the picturesque, the anecdotal, the "genre" subject. "In arranging and grouping together buffoons, male and female, tricked up like butchers and washerwomen in the carnival, in begging these heroes to be so good, during the time necessary for the operation, as to hold their smiles for the occasion, the photographer flatters himself that he is rendering

scenes of ancient history, tragic or noble." (Baudelaire)

Furthermore, painting had never been more "photographic" than in this period when the art of Niepce and Daguerre was expanding, a situation propitious for thriving confusion.

The present section shows how some painters were able to rise above the conflict by using methods the photographers had taught them. It also demonstrates how certain primitive photographers approximated painterly effects without becoming ridiculous.

This section does not pretend to advance any theory. In an area where charm and ambiguity blend so intimately, it seeks at best to prove that no rigid borderline exists between one art and another, and that there are alternatives to mutual excommunication.

74 Camille-Baptiste COROT. Le bouquet de Belle Forière. Positive print from cliché-verre, about 1858. 155x233

The "cliché-verre" technique was invented by the painter Dutilleux along with two friends, Grandguillaume and Cuvelier. Corot, an intimate friend of Dutilleux, began his first experiments in 1853. He is known to have made at least sixty-five clichés-verre between May, 1853 and 1874, proof of his continuing interest in this medium.

The cliché-verre was in fact a true negative, entirely handmade by engraving onto collodion, or by painting on a glass surface. Clichés-verre were

the most faithful original engravings possible.

William M. Ivins, Jr., in *Prints and Visual Communication*, states: "So far as the artist was concerned, it was a much more direct and simple process than etching. But because these prints were neither etchings, nor lithographs, and because they were not actually photographs made with a camera, they never became popular with collectors or the public."

This picture was made entirely with an etching needle.

75 Camille-Baptiste COROT. The Ambush. Positive print of a cliché-verre, 1858. 220x157

Corot smeared the glass surface with an opaque substance and with small sharpened sticks drew lines that came out black on the print. Coats of paint of different thickness created variations of tonality. It was actually a painting evolving into a photograph.

76 Camille-Baptiste COROT. Rembrandt's "Woodcutter." Cliché-verre transformed into a photogravure print, 1853-1855. 98x62

This was Corot's first attempt in the cliché-verre technique (1853). The original plate was destroyed, and only two prints from it are known to exist. Charles Nègre transferred this photographic image into steel by a method

he invented, thus obtaining a kind of etching shown here for the first time.

77 Constant DUTILLEUX. Landscape. Positive print from a cliché-verre, about 1855. 160x110

Dutilleux, a friend of Corot's since 1848, taught the famous painter the cliché-verre technique. Dutilleux is revealed here as a most capable technician.

78 Eugène DELACROIX. Poised Tiger. Print from a cliché-verre, drawn with an etching needle, 1854. 168x200

On March 7, 1854, Delacroix wrote to Dutilleux thanking him for initiating him into this new art form. About photography in general he continued: "As far as I am concerned, I can only say how much I regret such an admirable discovery should have come so late! The possibility of studying such images would have had an influence on me that I can only guess at from the usefulness which they have now, even in the little time left me for more intensive study. It is the tangible proof of nature's own design, which we otherwise see only very feebly."

79 Théodore ROUSSEAU. The Cherry Tree. Print from cliché-verre, drawn with an etching needle. 218x 277

80 *Excursions daguerriennes. Vues et monuments les plus remarquables du globe.* Paris, Lerebours: View in Normandy. Daguerreotype reproduced on copper plate by Salathé, 1841. 148x 203

The text accompanying this print states: "Amateurs almost despaired of being able to render views or landscapes successfully through the daguerreotype...skies develop with extreme speed...shades of green, and consequently all vegetation, only

emerge gradually..." Lerebours, however, surmounted these problems and boasted: "Small houses are accented admirably, and the foliage, superbly rendered, is a facsimile of nature..."

81 Eugène CUVELIER. Landscape in the forest of Fontainebleau. Positive print toned with gold from paper negative, October 19, 1863. (Collection of the Société Française de Photographie.) 198x257

Eugène Cuvelier was the son of one of the painter-photographers who had taught Corot the technique of the cliché-verre. He often went to Barbizon. Aaron Scharf has unearthed an interesting letter from Millet to Théodore Rousseau: "You must have seen Eugène Cuvelier. He showed me some very fine photographs taken in his own country and in the forest. The subjects are chosen with taste, and include some of the finest groups of timber that are about to disappear." (*Art and Photography,* p. 63.)

82 Eugène CUVELIER. Grass and shrubs. Positive print from a glass negative, October 22, 1863. (Collection of the Société Française de Photographie.) 198x258

Cuvelier apparently understood remarkably well the limitations and advantages of every photographic process. In the preceding print he takes advantage of the delightful softness of paper negatives and creates a picture that would have pleased Corot and Millet. In this picture, on the other hand, he capitalizes on the infinite sharpness possible in the glass image. This picture offers a singular contrast to the preceding example, of which Cuvelier was well aware. He showed the two prints side by side and with notes on the methods used at the Société Française de Photographie.

83 Hippolyte BAYARD. House and garden. Les Batignolles. Positive print from a paper negative, January, 1844. (Collection of the Société Française de Photographie.) 168x170

In his youth, Bayard sought the company of actors and painters, particularly of Dupuis of the Comédie Française, a friend of Amaury Duval, Ingres's pupil. Lacking talent himself, Bayard still took pleasure in the company of Charlet and Gavarni. His works reflect the tastes of the time, but one can feel the promising originality of this new process.

Hippolyte BAYARD. Four compositions. Modern prints by MM. Gassmann from original negatives preserved by the Société Française de Photographie. Between 1846-1848 (?).

84 Composition with hat. 202x176

85 The arbor. 171x229

86 Bouquet of flowers. 228x170

87 Attic. 231x166

The taste for picturesque arrangements was typical of Talbot, Bayard, Blanquart-Evrard, and Regnault, and these pictures reflect the popularity of Dutch painting in this period. Talbot stated: "We find sufficient authority in the Dutch school of art for us to choose scenes from daily life as representational material."

The final picture here gains in realism what it loses in picturesqueness. We come closer to "pure photography," and Atget is soon to come.

88 Anonymous. Still life. Positive print from a paper negative, 1852-1855. 331x263

This picture is reminiscent of many other compositions in a similar vein by H. Le Secq, negatives of which are preserved in the Bibliothèque Nation-

ale and the Musée des Arts Décoratifs in Paris.

89 Gustave LE GRAY. Boulders in the forest of Fontainebleau. Positive print from a wax paper negative. Gold chloride toning, 1851. 176x250

This photograph was taken in the forest of Fontainebleau at the height of Barbizon school fame when Millet decided to settle at the edge of the woods. E. Lacan wrote that it "looked as though it could have been painted by Diaz, in one of his more inspired moments."

90 Henri LE SECQ. Dwelling in the quarries of St. Leu. Positive print from paper negative, 1851. 326x227

Le Secq had a feeling for light and masses. His still lifes, his sculptures, and the landscapes he selected to evoke were always seen from a new angle, in a light that imparts depth and liveliness.

91 Edouard-Denis BALDUS. Windmill in Auvergne. Negative on wax paper, 1854. 340x445

"It is a masterpiece. One could not find a more brilliant, translucent or luminous entry. The waters are deep and clear, the windmill well situated in the background; the shadows alive and nowhere opaque, even in the most intensive shades. The lack of sky, theoretically unfortunate, lends an added sense of reality to this sombre yet ruggedly charming mountainside." (Exposition Universelle, 1855. Paul Périer's commentary in the *Bulletin de la Société Française de Photographie*, 1855, p. 192.)

92 Edouard-Denis BALDUS. Rocky Landscape. Negative on paper, before 1855. 347x450

This is doubtless the "fantastic landscape bristling with jagged rock for-

mations...which calls to mind the most vigorous canvasses of Salvator Rosa," shown at the International Exhibition of 1855.

93 Edouard-Denis BALDUS. Village and crucifix in Auvergne. Negative on wax paper, 1854. (Once in the collection of Petiot-Groffier of Chalon-sur-Saône, deceased in 1856.) 340x449

94 E.C. River's Edge. Positive print from paper negative, with barium salts toning, 1852. 253x322

Several photographers had the initials E.C. The name of Ernest Cousin comes to mind, or perhaps Eugène Cuvelier. This "River's Edge" heralds the photographic work of Peter Henry Emerson in the eighties. The very softness which adds charm to the picture is due to paper printing, and the artist-photographer turned this basically awkward process to advantage. Later, the development of glass plates produced such a precise focus that toward the turn of the century, photographers sought to create an overlay of softness which the primitives had immediately achieved by natural means.

95 E.C. Agricultural implements. Positive print from paper negative, with ammonium chloride toning, 1852. 260x325

96 DAVANNE (?) . Cottage. Photolithography, 1852. 157x222

"Using the asphalt process Niepce had experimented with in 1815, the four authors of this work, Lemercier, Lerebours, Barreswill, and Davanne obtained images on grained stones which could be printed on ordinary lithographic printing presses." This print is one of a collection which "contains the first reproductions of photographs succesfully made by their method." (Printing and the Mind of Man Ex-

hibition, London, 1963, No. 637.)

97 Louis-Désiré BLANQUART-EVRARD(?). Port in Northern France. Positive print from paper negative, about 1850. 170x223

This photograph comes from an album once in Blanquart-Evrard's personal collection.

98-101 Gustave LE GRAY. Seascapes. Positive prints from glass collodion, 1856. 325x415, 325x415, 325x415, 325x415

"Collodion emulsion was overly sensitive to blue light. As a result, when an exposure had been given that was long enough to record the landscape, the blue sky above was recorded on the negative as a solid tone: the print consequently appeared with a white, cloudless sky. This was intolerable to photographers who were emulating painters, and to remedy this shortcoming two negatives were often taken— one a short exposure to record the sky, the other longer, to record the landscape. The two negatives were masked; part of the print was made from one, and part from the other." (Beaumont Newhall, *The History of Photography*, p. 59.)

Le Gray initiated this method of "combination printing." *La Lumière* declared: "This is the event of the year; in London these pictures are creating a sensation."

102 Victor REGNAULT. The Ladder. Positive print made by Blanquart-Evrard from a wax paper negative, 1852(?) . 207x286

Regnault, who was President of the Academy of Sciences, did experiments in the realm of physics that remain classic. Along with Arago, Biot, Fizeau, and Foucault he followed closely the evolution of photography from its beginnings. In 1847, he tried the meth-

ods of Blanquart-Evrard; in 1851, he became a founder of the Société Héliographique, then President of the Société Française de Photographie.

Regnault became familiar with the techniques and art of English photography during several visits to England in the company of Herschel's son-in-law, John Stewart, also a photographer. Regnault, like Talbot, was not only an incomparable technician but also an artist of rare sensitivity. His choice of subject matter and his marvelous use of light bear evidence of a certain influence of English romanticism. His son Henri became one of the masters of "historic painting." The latter's fame was most probably the reason for Victor Regnault's later rejection of photography, denying any creative potential in the art.

With the exception of a few still lifes published by Blanquart-Evrard in his art albums between 1851 and 1855 his work was unknown until recently.

Victor REGNAULT. Landscapes taken at Sèvres and surroundings. Positive prints from wax paper negatives, 1851-1852.

103 Path between the Garenne de Sèvres and Gallardon. 324x408

104 Side door of the Sèvres Factory and the road to Meudon. 440x357

105 Sèvres, the Seine downstream near Meudon. 314x425

106 Sèvres, the carpenter's house on the banks of the Seine. 305x382

These pictures were taken in 1851 or 1852. Several were shown at the London Society of Arts in December, 1851. The catalogue of this exhibition opened with a foreword by J.F.W. Herschel and notes by his son-in-law John Stewart, describing Regnault's methods.

Regnault's works suggest a synthesis of French and English tastes in landscape. Unfortunately they impressed only a restricted few since his larger landscapes were never exhibited in France.

107 Charles NEGRE. L'Acquaiuolo. Positive print from a wax paper negative, 1852. 213x157

Nègre used this photograph in one of his paintings shown in the Salon of 1861. Three different versions of this photograph are known: with the subject front face, in profile, and from the back. Théophile Gautier took note of Nègre's paintings in the exhibition of 1861 and commented: "The daguerreotype which has not been mentioned by name and has received no medal nonetheless enhanced this exhibition..."

Charles NEGRE. Organ Grinder. Positive prints from wax paper negatives, 1852.

108 The organ grinder knocking on Charles Nègre's door, Quai Bourbon, Ile St. Louis. 100x82

109 Litle girl giving alms to the organ grinder. (The bearded man is the photographer Le Secq.) 165x215

To a contemporary critic this picture "made one think of Decamps' most forceful drawings," while "the wise old man's head, the minute details of his velvet suit, yellowish, threadbare, and sordid, remind one of Meissonnier's most scrupulously studied subjects." (*La Lumière*, September, 1853.) Nègre exhibited a painting of the Organ Grinder in the Salon of 1853.

110 Charles NEGRE. Chimney Sweeps. Positive print from wax paper negative, 1852. 160x215

Charles Nègre built a special lens

with a wide opening, and a diaphragm "structured more like the human eye." He could thus make exposures in a shorter time (a few seconds), even on paper.

This picture impressed many at the time: "In this naïve, picturesque, and striking scene Murillo relives completely." J. Adhémar notes that Nègre and Daumier were near neighbors on the Ile Saint Louis and has compared "Chimney Sweeps" with Daumier's "Burden."

111 Victor REGNAULT. Cleaning vegetables. Modern print from wax paper negative, about 1851. 204x153

This tableau reflects the taste of nineteenth-century minor artists like Bonvin and is comparable to contemporary studies by Charles Nègre.

112 Charles NEGRE. The Vampire. Positive print from wax paper negative, 1851. 325x230

Charles Nègre made his début at the same time as Henri Le Secq, who was equally enthusiastic for the art of the cathedrals which Victor Hugo had popularized. Nègre wished to associate his friend with his romantic vision of Notre Dame, and shows him in a proud posture.

113 Charles NEGRE. Oil presses in Grasse. Positive print from wax paper negative, 1852. 326x236

In the Salon of 1861, Théophile Gautier admired a painting by Nègre identical to this. He found in it a delicacy similar to that of Buttura. Our contemporary eye discerns other qualities here: luminous masses, overlapping of planes, and volumes evoking names of less obscure and more recent painters.

114 Adolphe BRAUN(?). Landscape. Positive print from a glass collodion

negative, about 1860(?). 220x290

Collodion offers an extremely "sharp" image, eliminating effects achieved with translucent paper negatives. On the other hand, light shadings, receding planes, reflections, distances, and misty passages are marvelously recorded, bringing to photography a charm unknown before.

115 JEANRENAUD. Path in the forest. Positive print from a glass negative, albumen(?), about 1859(?). 250 x325

116 Charles AUBRY. Foliage. Positive print from a glass collodion negative, about 1864. 467x373

Charles Aubry specialized in subjects for painters. Many still lifes by him are known.

"Photography has produced much information, spared the models much posing, given the artist accessories, draperies, and backgrounds that now need only to be copied in color." (Théophile Gautier.)

117 Anonymous. The Spring. Positive print from glass collodion negative, about 1855-1860. 222x162

The subject is reminiscent of Ingres; the model is more akin to Courbet. "One is struck by the resemblance of the photographers' nude models to those of Courbet, so it is hard to un-

derstand the hostility of the critics towards 'bathers so monstrously hideous as to make a crocodile lose his appetite,' according to Delécluze." (J. Adhémar.)

118-119 BRAQUEHAIS. Nudes. Positive prints from glass collodion negatives, 1853. 202x262, 250x201

The same model was photographed by Delacroix and Durieu in 1853. These pictures "were greatly admired by the painters to whom we showed them..." One study of a woman "swathed from head to foot in a gauze veil...creates a feeling similar to that evoked by Guérin's celebrated canvas 'Clytemnestra.'" (La Lumière, 1854.)

The World, A New Portrait

A few months after the dramatic revelation of the Daguerre process, his tract had already been translated into seven or eight languages and more than thirty editions issued. The process was put in use in the United States one month after its announcement in Paris.

In 1839, the optician Lerebours began to collect daguerreotypes from all over the world. He asked travelers to bring back pictures of famous sites. By 1841, he owned more than a thousand daguerreotypes from Russia, Sweden, Italy, the Orient, and even America, but only reproductions remain.

Known hitherto only through travelers' tales, the world was now directly exposed to the eyes of scholars and curious amateurs. Literary exoticism grew less poetic, but travelers' dreams were ardently aroused, and it cannot be gainsaid that photography may have played a part in the colonial hopes of the major powers during the Victorian era.

Dumont d'Urville roamed the Pacific in 1842, equipped with a daguerreotype camera; at the same time Siebold photographed Japan.

The great photographic expeditions signalled the ebb of a romantic view of the world. Gradually nations were to see each other more clearly, and photographic realism kept pace with the people's demanding realities.

Excursions daguerriennes. Vues et monuments les plus remarquables du globe. Paris, Lerebours, 1841-1844.

120 Muhammed-Ali's Harem in Alexandria. 155x205

121 Moscow. 155x210

For Lerebours, the painter Horace Vernet and his nephew Frédéric Goupil-Fesquet roamed the Near East, where they took pictures that astonished Muhammed-Ali, particularly this view of his harem taken in his

presence in two and a half minutes.

The finest engravers transposed these daguerreotypes into aquatints which remain impressive in their accuracy. The album includes views from Algeria, Syria, Russia, and Sweden.

Hector HOREAU. Panorama of Egypt and Nubia, Paris, 1841.

122 Thebes. Hypostyle Hall, Karnac. 397x282

123 Luxor. 280x445

The architect Horeau attempted to

reconstruct in one vast panorama the ancient Egyptian monuments in their prime. To these reconstructions he added a set of aquatints by Himely, showing the actual condition of the monuments. To this end he used daguerreotypes brought back by Joly de Lotbinière. Goupil-Fesquet met him on the same Nile boat, and together they made the first photographic survey of Egypt.

BISSON frères. Le Mont Blanc et ses glaciers, souvenirs du voyage de LL.

Majestés l'Empereur et l'Impératrice. Paris. Positive prints from glass collodion negatives, 1860.

124 Goûter Peak viewed from St. Gervais. 391x230

125 Goûter Peak from Bionassay, Dôme de Niage viewed from the valley of Contamines. 230x402

126 The Grand Mulets and the Dôme du Goûter viewed from Jonction. 235x415

The Bisson brothers tried to climb Mont Blanc in 1860 and brought back a remarkable set of pictures, although they were unable to reach the summit. Accompanied by twenty-five bearers, they succeeded the following year. To transport a tent-laboratory and expose and develop extra large plates at such altitudes was an amazing feat.

127 Vicomte VIGIER. Chaos of Gavarnie. Positive print from paper negative, 1853. 255x343

Vigier made a careful photographic study of the Pyrenees, in a hundred views, often in picturesque style.

128 Maxime DU CAMP. *Egypte, Nubie Palestine et Syrie. Dessins photographiques recueillis pendant les années 1849, 1850 et 1851.* Paris, Gide, and Beaudry, 1852. First installment launched as a prospectus. 488x325

In 1849, in the company of Gustave Flaubert, Du Camp made a journey to the Orient. Although Flaubert pretended to despise photography, he was of some help to his friend. Of the two hundred pictures Du Camp brought back, about a hundred and fifty were issued in small numbers. Later, two or three hundred sets of the best one hundred twenty-five were printed. This was the first important

photographic work published in France.

129 Maxime DU CAMP. Flaubert dressed as a Turk, in front of the Mousky house, January 9, 1850. Positive print made in Paris from paper negative, 1851. 213x148

130 Maxime DU CAMP. Nubia, Basrelief. Positive printed in Paris from paper negative, 1851. 225x167

131-136 Maxime DU CAMP. The Colossus of Abu Simbel. Prints made in Paris from paper negatives, 1851. (Plates 103 to 107 from the 1852 edition.) 217x167, 215x166, 218x168, 220x168, 228x165, 168x226

137 Maxime DU CAMP. Frieze and capitals at Baalbek. Printed in Paris from paper negative, 1851. 282x216

The seated figure may be Flaubert dressed as a Turk. "As to the Temple of Baalbek, I never thought one could fall in love with a colonnade; yet it is true. I must add the columns seem to be chased in vermeil because of the color of the stone itself and the sun." (Flaubert, letter to his mother, October 7, 1859.)

Louis DE CLERCQ. *Voyage en Orient, 1859-1860. Villes, Monuments et vues pittoresques. Recueil photographique.*

138 Jerusalem, Sixth Station of the Cross. 280x213

139 Jerusalem, Ninth Station of the Cross. 396x268

Louis De Clercq was twenty-three when he brought back this harvest of 222 photographs published in five enormous tomes. Enchanted by the Orient from childhood, De Clercq was an energetic collector for forty years. He died in 1901, and in November, 1968, the Louvre put on view a selection of six hundred rare objects bequeathed by his family.

De Clercq concentrated his camera on Syria, Palestine, Egypt, and Spain.

140 Désiré CHARNAY. Palace of the Nuns, Chichen-Itza. *Cités et ruines du Nouveau Monde,* Mexico-Paris, 1861. Positive print from a glass collodion negative, 1861. 268x400

A tireless traveler, Charnay came to America for the first time at the age of twenty-three. From 1857 to 1865, he studied Mexican ruins. During this period in 1863, he visited Madagascar; later, Argentina, then Chile and Java in 1878. In 1897 he traveled through Yemen.

His work on pre-Columbian architecture and the widespread influence of his research opened the eyes of the world to the grandeur of the New World's cultures and renewed the enthusiasm awakened by predecessors like Stephens and Catherwood. His photographs enjoyed a wide distribution due to the wood engraving process. They provide valuable information on the condition of the Yucatan monuments before restoration work.

141 Désiré CHARNAY. Aztec Calendar Stone, Mexico. Print from the original negative. 410x335

This print was included in the proposed large edition, soon abandoned, of *Cités et Ruines du Nouveau Monde.*

Désiré CHARNAY. Photographs of Madagascar. Positive prints from glass collodion negatives, 1863.

142 Islet of Madame at Sainte Marie. 160x288

143 Village of Kisuman, (northwest coast). 208x287

144 "Tacon" (filanjana or litter), means of transport in Madagascar. 144x201

145 Rice beaters. 197x156

146 Raharla, the Queen's Minister. 194x119

147 Group of Betsimisaraka women. 212x167

148 Madagascar widow. 168x105

149 Boabab on the island of Mohéli. 286x257

150 Vakoas in the Tamatave region. 244x202

While on an official diplomatic mission in 1863, Charnay took a series of photographs contemporaneous with those by William Ellis under the sponsorship of English missionaries.

In the tradition of artists on important maritime expeditions, Charnay amassed material of an historical, geographical, anthropological, and botanical nature.

Charnay wrote the story of his trip in *Le Tour du Monde* (1864), illustrated with woodcuts. Several examples are displayed with these photographs, which had been lost up to this time.

Gustave VIAUD. Photographs of Tahiti, 1859.

151 Bay of Papeete. Islet of Motu

Uta. Wax paper negative. 95x195

152 Fare Ute promontory with the Arsenal. Negative on wax paper. Modern collotype print. 191x252

These pictures, recently rediscovered, were made by the brother of the famous novelist Pierre Loti [Louis Viaud]. Gustave Viaud was a naval surgeon. The twenty-five or thirty prints he left comprise the first pictorial report on the island, and they show us, long before Gauguin, a Polynesia practically uncontaminated by modern civilization.

153 *Album photographique de l'artiste et de l'amateur*. Blanquart-Evrard, Lille, 1851. Plate 24, positive print from paper negative. 212x170

This is entitled Modern Hindu Temple at Mondlesir between Agra and Bombay, (Hindustan). The photographer who sent this picture to Blanquart-Evrard unfortunately remains unknown. The album includes four other pictures of ancient Indian temples, a view of Athens, and one of Jerusalem. This album forms the first collection of photographs ever published in France.

Pierre TREMAUX. *Voyages au Soudan Oriental...Exploration achéologique en Asie Mineure...Parallèle des édifices anciens et modern es du continent africain...Paris, 1847-1863.*

154 Cover of one of the installments. 555x368

155 View of a courtyard in Tunis. 254x188

156 Lithograph from the preceding photograph. 278x215

157 View of one of the statues on an avenue in Milet. 255x194

158 Turkish stèles. Photolithograph, Poitevin process. 263x204

Publication of Trémaux's *Voyages* stretches over a period of about fifteen years, during which new methods of reproduction appeared in the book. The methods successively used were traditional lithography from drawings, photography (which faded and had to be replaced during publication), lithography traced from original photographs, and finally the most recent, photolithography.

Faces of Mankind

The study of man's countenance through even the most penetrating portraits is only a partial approach to the question of facial interpretation.

Studious artists of the Renaissance were deeply conscious of the importance of the theoretical study of human forms. Luca Pacioli, Leonardo, and Dürer sought the vision of divine perfection in the ideal proportions of man. Artists, scholars, philosophers, and seers have endlessly sought to catalogue human facial expressions. Among them some tried an opposite direction, divining what passions, vices, or traits left their mark on man's countenance.

Duchenne de Boulogne seems to mark the end of this centuries-old quest. The rationalism of his systematic analysis of each separate muscle, along with the fixing of every experiment on photographic plates made unequalled material available to specialists. Extending his probings into the domains of the theater and sculpture, he successfully synthesized earlier findings which he incorporated in his work. His idiom was that of Le Brun, but Darwin was to make use of his work.

Anthropological research by the Museum d'Histoire Naturelle and by Prince Roland Bonaparte and Bisson frères, sought to provide insight into the general characteristics of the various human races. Asiatics and Scandinavians, masters and slaves, full face and profile, all solemnly revealed the dignity of their race. Beside such scientific series, the portraits of famous men may seem to us a curious gathering of colorful personalities.

We know moreover that Nadar was directly associated with the projects of Duchenne de Boulogne. Scientific facts which he had assimilated by 1856 formed a criterion according to which he was able to disclose what "most human quality" lived

in each individual.

"One last time, in the fleeting expression of a man's face, these old photographs leave room for 'the aura.' This is what gives them their incomparably sad beauty." (Walter Benjamin)

"These men that Nadar photographed around 1860 have been dead these many years. But their gaze remains and the world of the Second Empire lives forever before their eyes." (Jean-Paul Sartre)

159 Hippolyte FIZEAU. Portrait of the engraver Hurlimann. Photogravure from a daguerreotype, by the Fizeau process, 1841. 90x68

Hurlimann was an extremely skillful engraver. He lived on the rue du Four and his neighbor Fizeau, who lived on the rue du Cherche-Midi, made use of his talents to carry out his experiments. One of the earliest examples in France of a portrait on paper, this picture reveals the degree of perfection already achieved. The death of Hurlimann in 1842 and the patent registered by Fizeau in 1843 doubtlessly were reason for the disuse of this method which totally eliminated the two drawbacks of daguerreotyping: brightness and the single image.

160-161 E. BENECKE. *Voyage en Egypte et en Nubie*. Positive prints by Blanquart-Evrard from paper negatives, 1852. 218x157, 174x218

Practically nothing is known of Benecke whose technique was more refined than that of Du Camp, allowing him to bring back some interesting data on man and his activities.

162 Fouka-Sawa, official in the Japanese Embassy, born in Tokyo. Anthropological Collection of the Muséum de Paris. Positive prints from collodion negatives. Photographer unknown. 190x150

163-164 Prince Roland BONAPARTE. Anthropological Collections: North American Indians. Positive prints from collodion negatives, about 1860. 225x170, 225x170

Anthropological collections: Laplanders. Collotype from the original photographs. Photographer unknown.

165 Peter Johan Abrahamsen. 160x118

166 Ellen Nielsdatter. 160x118

The daguerreotype was the death blow of the miniature, and a number of unemployed artists took jobs in photographers' studios to color daguerreotypes or to paint the first images on paper.

167 Photographer unknown. Portrait of an old woman in a lace cap. Painted photograph, about 1850-1860. 246x 290

168-170 Hippolyte BAYARD. Self portraits, calotypes. Modern prints from the original negatives, about 1846. 220x166, 173x225, 225x163

In this work, Bayard used the Talbot method, and posed himself. His pose, with eyes shut, would indicate the exposure was very long.

171 Hippolyte BAYARD. Self portrait. Positive print from collodion negative, about 1850-1855. 342x263

After uncovering the lens, the artist posed in complete rigidity. One can see faint traces of his movements and discern certain objects behind him exposed on the negative before he assumed his pose.

172 Louis Désiré BLANQUART-EVRARD. Portrait of his daughter. Positive calotype, 1846. 208x163

One of the Blanquart-Evrard's earli-

est efforts, shown at the French Institute in January, 1847.

Louis Désiré BLANQUART-EVRARD. Portrait of Jean-Baptiste Biot photographed in his laboratory in January, 1847. Positive print from paper negative. 61x49

173 Claude Félix Able NIEPCE de SAINT VICTOR. Self portrait. Positive print from albumen negative, about 1850. 210x155

The albumen process, invented by Niepce, rendered details with great precision; however, its use in portrait-making was unusual because of the long exposure required.

174 Victor REGNAULT. Self portrait, bareheaded. Modern print from wax paper negative, about 1851. 200 x154

This print, like the nine following, was made by Jean-Pierre Sudre from the original negatives preserved by the Société Française de Photographie.

175 Victor REGNAULT. Self portrait wearing a cap, about 1851. 209 x162

176 Victor REGNAULT. Portrait of a woman in profile with eyes closed, about 1851. 161x125

The subject is probably the scientist's wife. Her eyes are closed because of the long exposure.

177 Victor REGNAULT. Two children in an armchair, about 1851. 135x130

The children are the photographer's sons. Henri, the younger, on the left,

became the well-known historical painter, and the Louvre acquired several of his paintings.

178 Victor REGNAULT. Child in a cradle, about 1851. 123x155

179 Victor REGNAULT. Portrait of Jean-Baptiste Biot, signed and dated 1851. 194x154

This portrait of the famous physicist and chemist was made at the Collège de France. A similar portrait made in 1847 by Blanquart-Evrard in the presence of Regnault is known. Biot was deeply interested in the study of light.

180 Victor REGNAULT. Portrait of Claude Bernard, about 1851. 200x160

This may well be the oldest photograph of the celebrated founder of experimental physiology. In 1851, Claude Bernard had published only a few notes, but fellow scientists had already recognized his eminence.

181-182 Victor REGNAULT. Portraits of two scientists(?), about 1851. 190x160, 225x174

183 Victor REGNAULT. Portrait of a servant(?), about 1851. 206x163

184 Anonymous. Portrait of a man, about 1850. 205x142

185 Charles NEGRE. The painter Yvon. Positive print from wax paper negative, about 1852. 208x163

186 Charles NEGRE. Three friends of Nègre (Yvon one of them), photographed on the banks of the Seine. Positive print from wax paper negative, about 1852. 160x206

Charles HUGO, François HUGO and Auguste VACQUERIE. Portraits taken during their exile in Jersey. Positive prints from negatives on paper, 1852.

187 Victor Hugo in profile. 150x80

188 Victor Hugo and Auguste Vacquerie reading. 105x80

Victor Hugo was intensely interested in photography and gave incentive to those around him. His sons and Vacquerie used the calotype, collodion, and albumen. The pictures from Jersey and Guernesey are stamped with a strong romantic vitality.

189 Charles NEGRE. Portrait of Rachel. Positive print from glass collodion negative, 1853. 188x150

Nègre took this portrait of the celebrated tragédienne at Auteuil in 1853. Compared to the pretentious studies made by Pierson, this one has a charm and simplicity which explain Rachel's preference for it. On her tour of Russia she brought along fifty copies.

Guillaume-Benjamin Amant DU CHENNE de Boulogne. *Mécanisme de la physionomie humaine ou analyse électro-physiologique de l'expression des passions*, Paris, J. Renouard. Positive prints from glass collodion negatives, 1862.

190 Title and frontispiece showing the author at work, from the original edition of Duchenne de Boulogne's work. 280x190

191 Plate 32: True natural laugh. 111x87

192 Plate 21: right: Painful memory, left: memory and stimulus to remembering. 111x87

193 Plate 59: Fear. 111x87

194 Plate 63: Expression of terror. 111x87

195 Plate 64: Dread mixed with pain, torment. 111x87

196 Plate 8: "...The raven himself is hoarse.

That croaks the fatal entrance of Duncan

Under my battlements. Come, you spirits

That tend on mortal thoughts! Unsex me here,

And fill me from the crown to the toe top full

Of direst cruelty; make thick my blood,

Stop up the access and passage to remorse,

That no compunctious visitings of nature

Shake my fell purpose, nor keep peace between

The effect and it!" 111x87

197 Plate 72: "The modeling of the sides of the forehead is impossible." 111x87

Duchenne de Boulogne continued the projects of Lavater and even those of Lebrun, which go back to the seventeenth century. He used their terminology. His aim was to examine each muscle separately to determine its role in the play of facial expression. From 1852 to 1856 he took collodion photographs of every reaction of a mentally debilitated patient. He made aesthetic comparisons, asking actors deliberately to duplicate expressions he obtained artificially through the application of electrodes. Going further, he analyzed anatomical errors in the Laöcoon, and portrayed the agonized countenance of a woman whom he compared to Lady Macbeth, heightened with verses from Shakespeare. These studies in comparative physiology and psychology have broad implications in themselves, but they take on their full importance if we keep in mind that Adrien Tournachon took some of the pictures. At that time Adrien Tournachon (Nadar, the young-

er) joined forces with his brother Félix, the famous Nadar. From the start they were able to analyze scientifically the slightest expression of the human physiognomy. At the exhibition of 1855, Messers. Tournachon & Co. enjoyed huge success with their portraits of the mime Debureau, entitled "Expression of fear; concentration, surprise, tenderness…"

198 Photographer unknown. Portrait of a man. Positive print from a glass collodion negative, about 1855-1860. 198x150

NADAR. (Gaspard Félix Tournachon.) Portraits. Positive prints from glass collodion negatives.

199 Eugène Pelletan, about 1854. 227x177

200 Gustave Doré, about 1854. 233 x185

201 Théophile Gautier, bareheaded, about 1857. 238x186

202 Théophile Gautier, wearing a cap, about 1857. 284x210

203 Hector Berlioz, about 1863. 238 x186

204 Jean Louis Ernest Meissonier, about 1863 (?). 263x200

Nadar is without question the greatest name in French photography. His portraits are utterly honest and most expressive. For him portraiture was "the most valuable as well as the most exacting" form of photography. He delved into the personality of every sitter with great perspicacity: "The

portrait I do the best is that of the man I know the best."

205 Etienne CARJAT. Portrait of Victor Hugo. Positive print from glass collodion, September, 1862. 252x185

Carjat is one of the few great portrait photographers whose talent approached Nadar's, but whose memory has been eclipsed by the better-known reputation of his famous rival.

206 Etienne CARJAT. Portrait of Daumier, about 1870. Modern enlargement from the original collodion negative. 380x285

207 Etienne CARJAT. Portrait of Courbet. Modern enlargement from the original collodion negative, about 1870. 380x283

translated by Emlen Etting and Marthe LaVallée Williams

List of Works Lent to the Exhibition by the George Eastman House

208 BERTAUTS (Imp.). Harbor Scene. Two color photolithography. 1864. 168x224

209 H. FIZEAU. Double portrait. 1844. Daguerreotype engraving. 90x67

Ildefonse ROUSSET. *Le Bois de Vincennes.* Paris, 1866.
210 "Rivière Aimable. (Partie couverte)." 177x138

211 "Asile Impérial." 107x190

212 "Une des 16 travées du kiosque de Gravelle (Coté de Pontenay)" 171 x129

213 Henri LE SECQ. Garden scene. n.d. Positive print from paper negative. 326x247

214 Henri LE SECQ. Dieppe (?). n.d. Positive print [1930] from paper negative. 344x246

215 Henri LE SECQ. Dieppe (?). n.d. Positive print [1930] from paper negative. 343x246

216 Henri LE SECQ. Still Life, *Fantaisie Photographique* n.d. (ca. 1856). Positive print [1930] from paper negative. 260x356

217 Henri LE SECQ. Vase of Flowers, *Fantaisie Photographique* n.d. (ca. 1856). Positive print [1930] from paper negative. 353x256

218 Henri LE SECQ. Chartres. ca. 1852. Positive print [by Edward Steichen, 1937] from paper negative. 353x278

219 Henri LE SECQ. Rustic Scene. n.d. Positive print from paper negative. 220x324

220 NADAR (Félix Tournachon). Portrait of Camille Corot. Much later print by Paul Nadar of father's negative, ca. 1854-59. 223x162

221 REUTLINGER, Charles. Portrait of Edouard Manet. 1875. Woodbury-type by Goupil et Cie. From *Galerie*

Contemporaine, Littéraire, Artistique, 1876. 120x82. On decorated page by E. Grasset.

222 Charles MARVILLE. Landscape. 1857. Positive print from paper negative. 261x357

223 Adolphe BRAUN. Flowers. n.d. Albumen print from collodion negative. 307x246

224 Adolphe BRAUN. Camelias and Lilac. 1856. Albumen print from collodion negative. 447x487

225 DISDERI & WIERTZ. Portrait of Marechal Magnan. n.d. (1860's). Enlargement of a carte-de-viste collodion negative, painted on by the painter Wiertz (probably Antoine). 573x408

226 PIALLAT. Warehouse of Edmond Ganneron, *Spécialité de matériel agricole.* Photolithograph. n.d. (Imp. Bertauts.) 354x462

227 Anonymous. Return of the Troops from Italy. 1852. Daguerreotype. 67x66

228 Anonymous. Portrait of a young man. n.d. Hand colored daguerreotype. 118x92: oval.

229 Anonymous. Portrait of a man. n.d. Hand colored ambrotype. 95x74: oval.

230 ALLEVY. Portrait of the deceased Dr. Amussat. Daguerreotype. 67x56

231 DELEMOTTE & ALARY. Médéak. Daguerreotype. 73x98

232 GODQUIN. Portrait of a watchmaker. Daguerreotype. 98x72

233 A. BERTRAND. Portrait of a man. Hand colored daguerreotype. 96x69

234 M. et Mme. DISDERI. Portrait of a Young Military Man. Hand colored daguerreotype. 61x50: oval.

235 Anonymous. Portrait of a woman. Hand colored daguerreotype. 119x 90: oval.

236 Anonymous. Portrait of a woman. Daguerreotype. 72x58: oval.

237 Anonymous. Portrait of a woman. Hand colored daguerreotype. 73x 60: oval.

238 Anonymous. Portrait of a young girl. Daguerreotype. 148x112

Mme. DISDERI. *Brest et ses environs.* ca. 1856.

239 "Cimétière de Plougastel, groupe de paysans." 294x224

240 "#6. Chalet à Enghien." 260x395

241 "St. Mathieu, intérieur." 268x200

Edouard-Denis BALDUS. *Chemin de fer du nord.* Paris, n.d.

242 "#24. Vue de Creil." 285x433

243 GODEFROY. Panorama of Paris. 1874. 9 accordion folded positive prints from glass collodion negatives. 368x2512

List of Works Lent to the Exhibition by the Metropolitan Museum of Art

244 Adolphe BRAUN. Port of Marseille. 1855. 17½x12

245 Adolphe BRAUN. The Garden. 16⅜x14½

246 Adolphe BRAUN. The Court of Napoleon III at Fontainebleau. June 24, 1860. (in three parts) 19⅛x15⅛, 19x15, 19x15